200 GREAT PAINTING IDEAS
for Artists

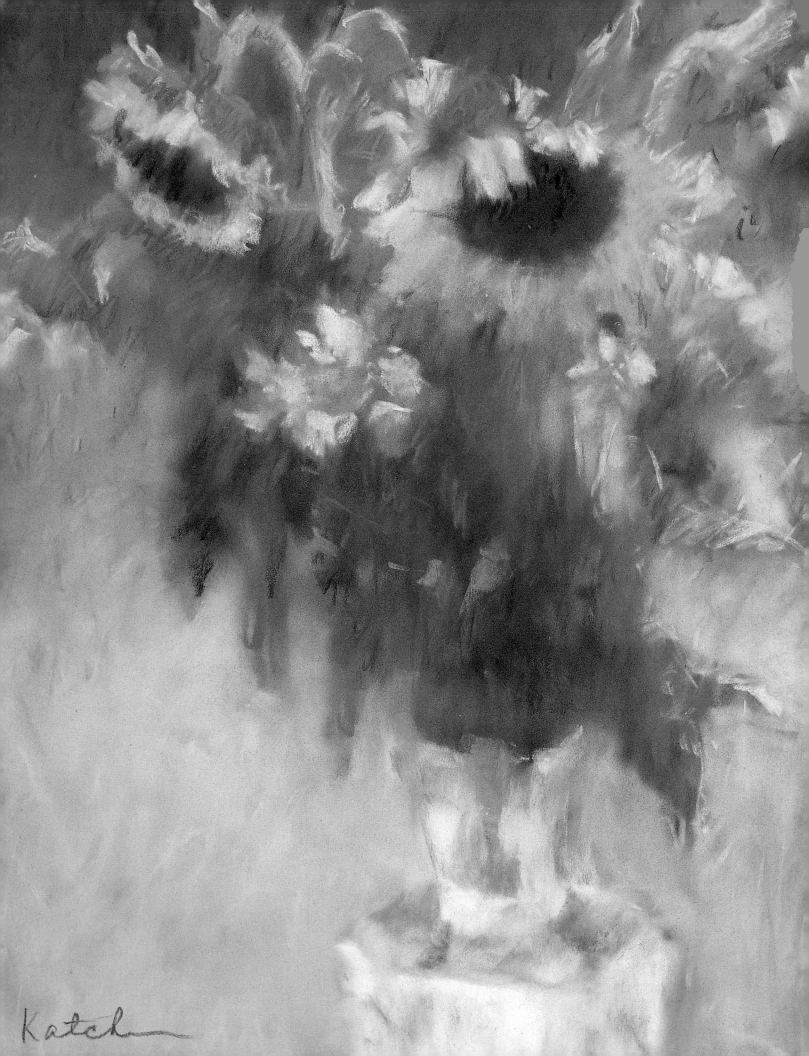

200 GREAT PAINTING IDEAS
for Artists

CAROLE KATCHEN

NEW YORK SUNFLOWERS
Carole Katchen, Pastel
25" × 19" (63.5cm × 48.3cm)

NORTH LIGHT BOOKS
CINCINNATI, OHIO

DEDICATION

This book is dedicated to all the artists who have shared their great ideas with me through the years.

ACKNOWLEDGMENTS

A big thanks to the editors and designers who made this book possible: Pamela Seyring, Rachel Wolf, Bob Beckstead and Brian Roeth.

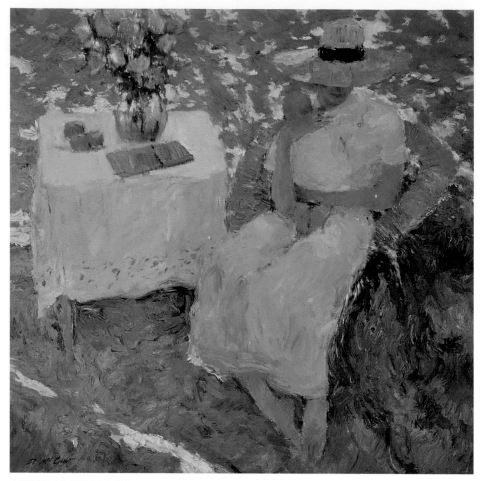

AFTERNOON LIGHT
Dan McCaw, Oil, 30" × 30" (76.2cm × 76.2cm)

200 Great Painting Ideas for Artists. Copyright © 1998 by Carole Katchen. Manufactured in Singapore. All rights reserved. No part of this book may be reproduced in any form or by any electronic or mechanical means including information storage and retrieval systems without permission in writing from the publisher, except by a reviewer, who may quote brief passages in a review. Published by North Light Books, an imprint of F&W Publications, Inc., 1507 Dana Avenue, Cincinnati, Ohio 45207. (800) 289-0963. First edition.

Other fine North Light Books are available from your local bookstore, art supply store or direct from the publisher.

02 01 00 99 98 5 4 3 2 1

Library of Congress Cataloging-in-Publication Data

Katchen, Carole.
 200 great painting ideas for artists / by Carole Katchen.
 p. cm.
 Includes index.
 ISBN 0-89134-799-2 (hc : alk. paper)
 1. Painting—Technique. 2. Painting—Themes, motives. I. Title.
ND1500.K279 1997
751.4—dc21 97-23677
 CIP

Edited by Pamela Seyring
Production edited by Bob Beckstead
Designed by Brian Roeth

ABOUT THE AUTHOR

A professional artist for more than thirty years, Carole Katchen has been awarded the Master Pastellist designation by the Pastel Society of America. Her pastels and other paintings have been honored in galleries and museums throughout the United States and in South America. She has written sixteen books of which one million copies have been sold, most recently *How to Get Started Selling Your Art* and *Painting With Passion* (North Light). She is listed in *Who's Who in the World*, *Who's Who of American Art* and *Who's Who of Women in the World*. She lives in Hot Springs, Arkansas.

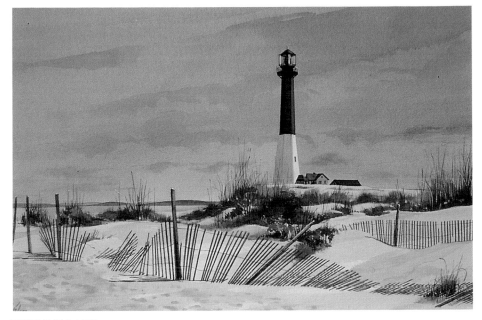

TYBEE ISLAND
Wilbur Elsea, Watercolor, 16" × 22" (40.6cm × 55.9cm)

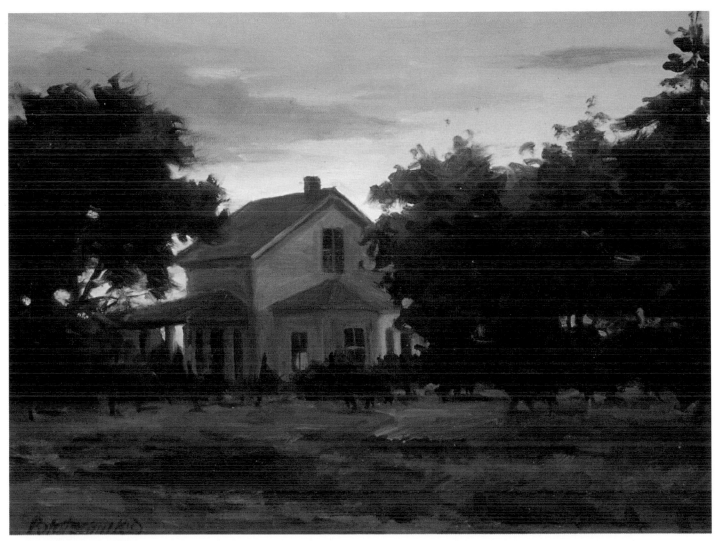

MIDWESTERN SUNSET
John Pototschnik, Oil, 9" × 12" (22.9cm × 30.5cm)

TABLE OF CONTENTS

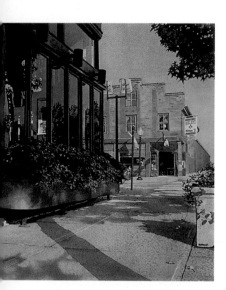

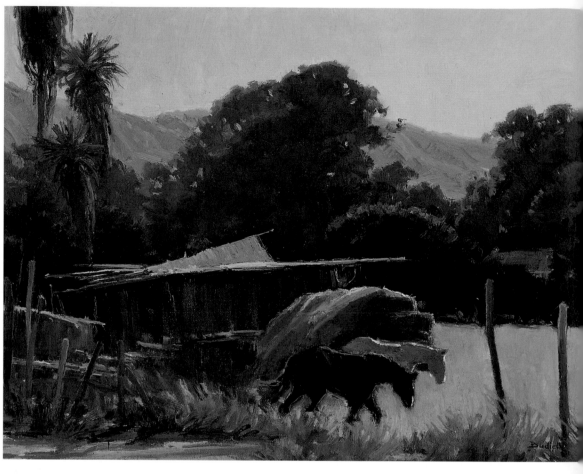

Take a New Look at Some Familiar Subjects

Examine the Elements of Painting

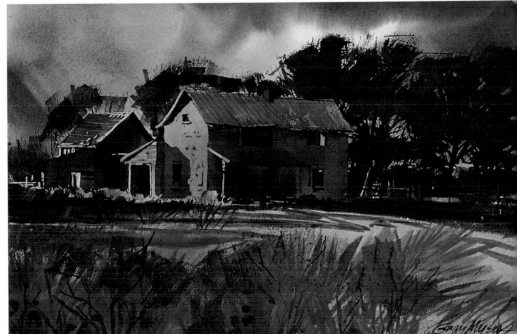

Find Your Inspiration

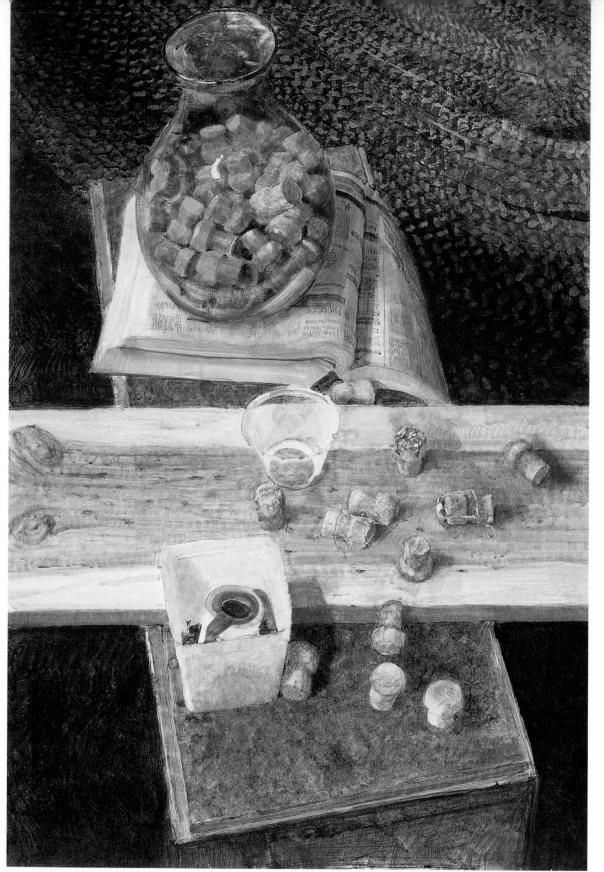

THE CORKS
Jerald Silva
Watercolor
48" × 28"
(121.9cm × 71.1cm)

IDEA #1 | PAINT A GROUP OF "BORING" OBJECTS

The subject of this painting is a collection of insignificant objects—a bottle of corks, the yellow pages, a wooden plank, a rag rug, a plastic cup. How did Silva turn them into a fine painting? He added dramatic lighting, focused on textures and arranged the objects in a dynamic design—notice the large X in the center of the composition.

Introduction: Looking for Great Ideas

In painting classes and workshops, students ask me, "What should I paint?" The problem is not that they don't have any ideas—they just don't think their ideas are good enough. Frankly, any idea for a painting is a good idea if you care enough about the subject to paint it well. That is the key: *caring* about the subject.

Each artist brings something special to the painting—such as enthusiasm. If I am fascinated by the shape of this particular rose, if I am enthralled by its intense color, if I am intrigued by the pattern of highlights and shadows falling across its petals, then this rose becomes a wonderful subject. Look at the flowers in this book by Mary Beth Koeze (page 16). You can't help but see her love of each particular blossom.

Another thing the artist brings is imagination. What would that model look like if I lit her from behind, above or below? What kind of background could I use to make her look more interesting? What unexpected props could I include in the composition? Look at the figures by Jerald Silva and Dan McCaw (pages 50-59). Their models are simply people like you or me, but they become special because of the artists' imagination.

The technical skill an artist brings can make a subject more exciting. Notice the virtuosity in Jeff Legg's still lifes (pages 14-15). His artichoke is more than an artichoke because Legg has learned to make paint glow on the canvas.

Finally, the artist brings courage. Painting something important to you just because you care about it, regardless of whether anyone else will think it matters—that is painting with courage. Whether you paint surrealistic images like Galardini and Criswell (pages 134-137) or capture simple moments of everyday life like John

Pototschnik (page 18), it takes courage to share your vision with the world.

This book is a gallery of wonderful ideas. Nearly seventy artists share their ideas for painting unusual or ordinary subjects in extraordinary ways. We invite you to try them, and to use them as inspiration for coming up with your own exciting subjects for paintings.

IT'S WHAT YOU BRING TO IT

Most ideas have been painted a thousand times. Still lifes, landscapes, florals, figures. These are themes that have been executed for hundreds of years. A rose is a rose; a peach is a peach. What makes this peach worth painting? It is what each artist brings to the subject.

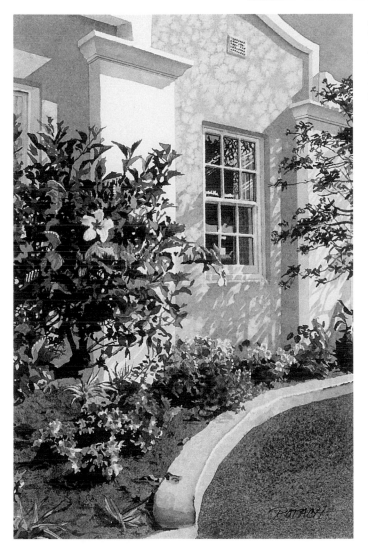

ARIEL'S WINDOW
Marlin Rotach
Watercolor
12" × 8"
(30.5cm × 20.3cm)

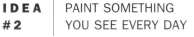

IDEA #2 | PAINT SOMETHING YOU SEE EVERY DAY

Look at the abstract design elements of potential painting subjects. This painting works because Rotach recognized the relationships of color, light and shape. He also took the time to render the subject well.

TEMPTATION
IN THE
AFTERNOON
Carole Katchen, Oil
36" × 24"
(91.4cm × 61.0cm)

| **IDEA #3** | PAINT AN ABUNDANT PARTY SCENE |

This party scene contains people, flowers and, of course, food. I wanted to suggest abundance, so I painted a great variety—meat, fish, bread, salad, pastry. I chose the individual items because of their color and shape. I unified the many forms, textures and colors by using rounded shapes for the dishes, bowls and much of the food. These repeated circles add rhythm and harmony to the overall composition.

Celebrate Food

What's the one subject *everyone* is interested in? Food. Even when we're not eating, we're buying food, preparing food, talking about it or just thinking about it. We love food, and if emotional intensity is a guide to good subjects for painting, then food must be right at the top of our list.

The trick to painting food well is seeing its abstract components: shape, size, value, color and texture. Three pears, two apples and a banana are three triangular green shapes, two round red shapes and a thin yellow crescent.

Like any other still-life subject, food objects must be arranged to create an eye-catching design. They should be lit so their highlights and shadows provide maximum drama. Shapes and colors should be planned for both contrast and harmony. They should also look delicious.

Successful paintings are of subjects the artist loves. So if you *love* chocolate, why force yourself to paint trees or old barns? Paint chocolate!

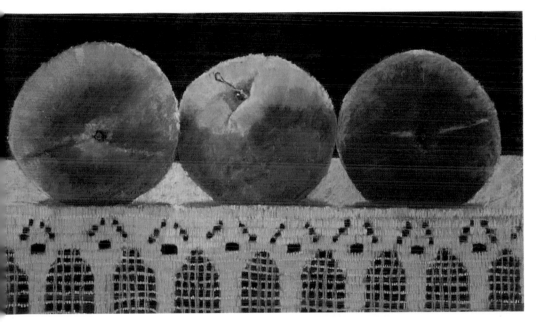

IDEA #4 | PAINT SOMETHING DELICIOUS

Look at how ripe and juicy these peaches seem. Emrich used full, round shapes for the fruit. Notice the contours are blurred and irregular in places; this enhances the three-dimensional effect. The choice of warm colors for the fruit helps make it look ripe.

CALIFORNIA PEACHES
Lilienne Emrich, Pastel
17" × 27" (43.2cm × 68.6cm)

IDEA #5 | CUT UP PIECES OF FRUIT FOR INTEREST

Slice or section a piece of fruit to get interesting repetition and contrast of shape. The darker color of the skin surrounds the lighter flesh and the seed core gives a dark accent to each piece. When you cut up fruit it darkens quickly, so you have to paint fast.

NOT A PAIR
Dolores Justus, Watercolor, Colored Pencil
10" × 20" (25.4cm × 50.8cm)

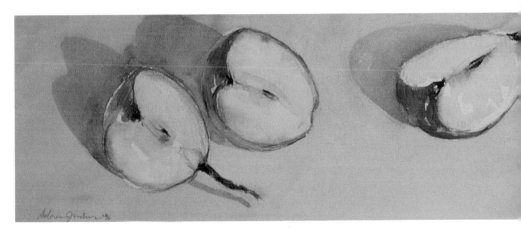

IDEA #6 | WHIP SOMETHING UP

This wonderful painting includes lemons, knife, juicer and a glass of lemonade. By including the implements and the lemons, Moody has included the viewer in the process of making the lemonade. A painting that tells a story is more engaging for the viewer. Because so much of our food comes processed today, a painting about preparing food from scratch often conveys a welcome sense of nostalgia.

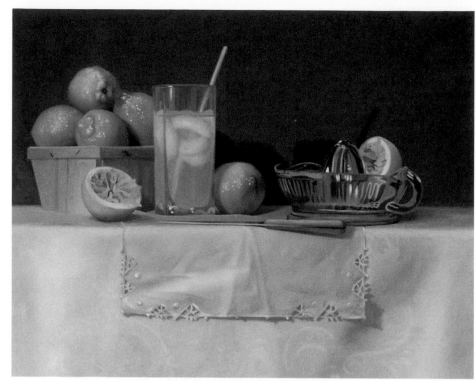

LEMONADE
Sharon Moody, Oil
18″×22″ (45.7cm×55.9cm)

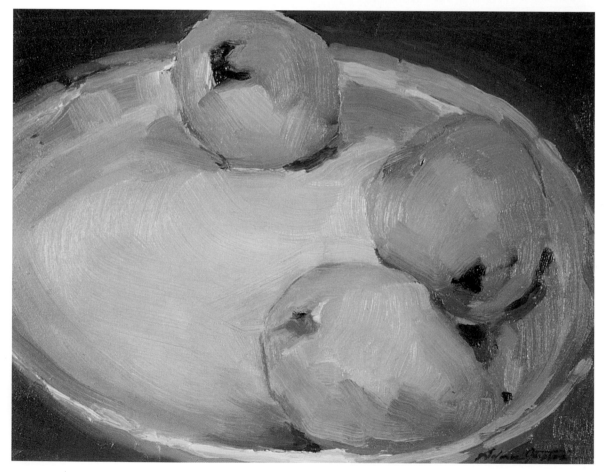

IDEA #7 | ACCENT YOUR FOOD WITH A PLATE

A plate can create a frame for what you put on it. The oval surrounds the pears, unifying the composition. The artist repeated the yellow on the plate.

POINTS OF INTEREST
Dolores Justus, Oil
8″×10″
(20.3cm×25.4cm)

Tips on Painting Food

• The biggest difficulty in painting food is that so much of it is perishable. It withers, wilts, melts and rots. Mushrooms, for instance, have wonderful shapes and textures, but in a very short time they shrivel up. If you are painting from life, complete the items that change most quickly (like mushrooms) first; then paint the squash, apples or onions.

• Keep a Polaroid camera handy to capture those most perishable items.

• For resource materials, keep a stack of gourmet and women's magazines handy. Cookbooks also have wonderful color photos of food.

• Two pitfalls with fruit:

1. Pure, round circles never look like real fruit. Straight lines are also very rare. Use your eyes to see and capture the actual contour with all of its bumps and crevices.

2. Outlines tend to flatten out a three-dimensional form. Minimize hard edges around the objects. By blending some of the edges you will make the objects seem more solid.

MORNING LIGHT
Bill Lewis, Watercolor
12" × 15"
(30.5cm × 38.1cm)

IDEA #8 | CONSIDER FOOD AS DESIGN ELEMENTS

This painting shows basic design elements. Round apples contrast with the long shapes of the bananas. Two red apples sit in one corner, balanced by one apple and its red shadow in the opposing corner. The red and yellow of the fruit bleed into the surrounding space for color harmony. Blue accents balance each other in the upper right and lower left corners.

IDEA #9 | OPEN A PACKAGE OF TREATS

What a wonderful surprise—an elegant painting from packaged cupcakes! Combining them with the elegant white roses creates a provocative contrast. Notice that the painting also works on a purely visual level, the rose shapes in the upper left balanced by the repeated cupcakes at lower right. The powerful shape of the cast shadow anchors the painting on the bottom and the yellow triangle of butter completes the composition.

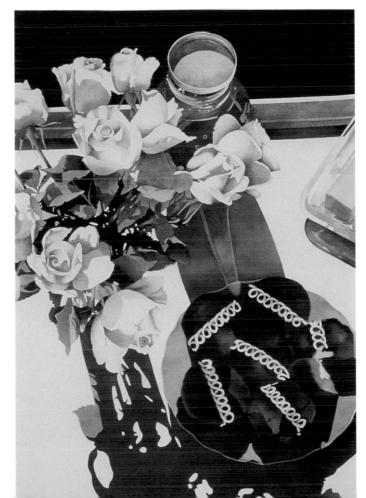

ROSES WITH
LITTLE DEBS
Butler Steltemeier
Watercolor
18" × 24"
(45.7cm × 61.0cm)

13

DEMONSTRATION
Paint Fruits and Vegetables

IDEA #10 | RAID THE REFRIGERATOR
FOR A VARIETY OF SUBJECTS

Your refrigerator can be an endless source of subjects for
paintings. Fruits and vegetables are the most obvious sub-
jects, but don't overlook the visual possibilities of eggs, a
hunk of cheese, pimento-stuffed olives and all the other
brightly colored and oddly shaped objects within.

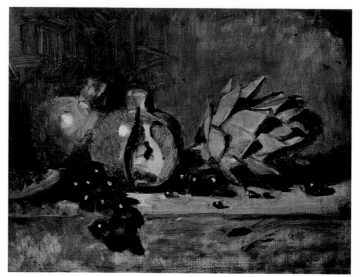

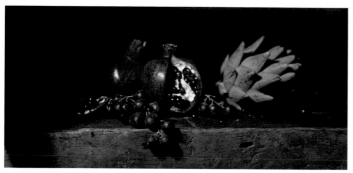

STEP ONE
Arrange the Setup

Jeff Legg begins a painting by arranging his objects in the studio.
By using the actual objects, he's able to move them around
and change the lighting until he achieves the most pleasing
composition.

STEP TWO
Lay in Shapes

First he lays in the shapes with Burnt Umber oil paint. He uses
quick strokes of fairly thin paint, careful to place the highlights
and shadows from the beginning.

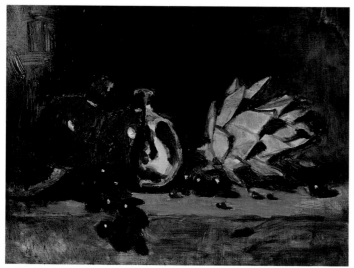

STEP THREE
Paint in Color

He paints in the color one element at a time; first the grapes, then
the pomegranates. Notice how he retains the shapes and values
he established in his underpainting.

STEP FOUR
Refine Details

Once all the main shapes are laid in, he starts to refine contours
and add details. Notice how he repeats colors throughout the com-
position—red in the pomegranates, seeds and highlights on the
grapes, green in the artichoke and the stems of the grapes. Re-
peated color adds harmony and balance.

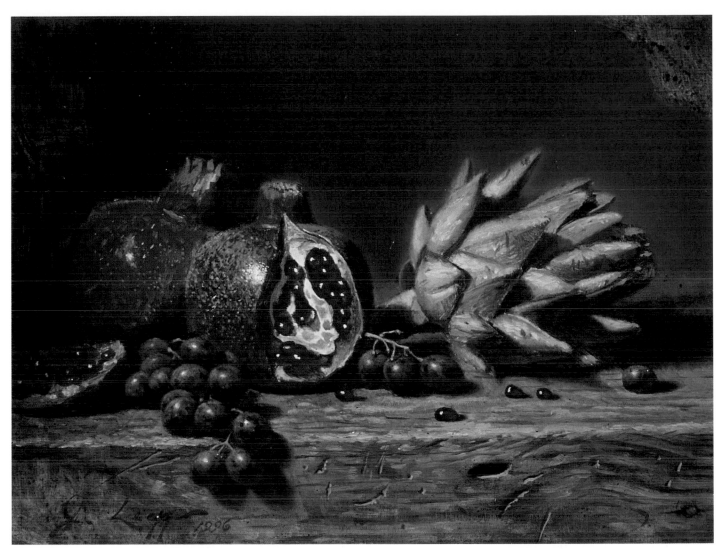

STEP FIVE
Finish the Textures
The final step is to capture all the textural details: the speckled pomegranate skin, the battered wood, the frosted grapes. Legg leaves corners of the background unrefined to provide color balance with the brown wood and also to tweak the viewer's interest.

POMEGRANATES AND ARTICHOKE
Jeff Legg, Oil
9" × 12" (22.7cm × 30.5cm)

More Delicious Ideas

IDEA #11 | MAKE A STILL LIFE FROM JARS OF FRUIT, VEGETABLES AND CONDIMENTS

Look for variation in color and shape. Consider both the shapes of the containers and of the foods within; for instance, a round jar of preserved cherries next to a tall jar of pickled string beans.

IDEA #12 | SET A TABLE FOR AFTERNOON TEA

Include a beautiful teapot, cups, saucers, dishes, silver and tablecloth. Add a few serving plates of scones, cookies, small cakes or finger sandwiches. Don't forget a gracious arrangement of flowers.

IDEA #13 | POUR A PACKAGE OF COLORFUL CANDIES ONTO A TABLETOP

Arrange the candies into an interesting design of individual and grouped pieces. Include the cellophane wrapper as a visual contrast. This type of subject is most effective when executed in a very realistic way.

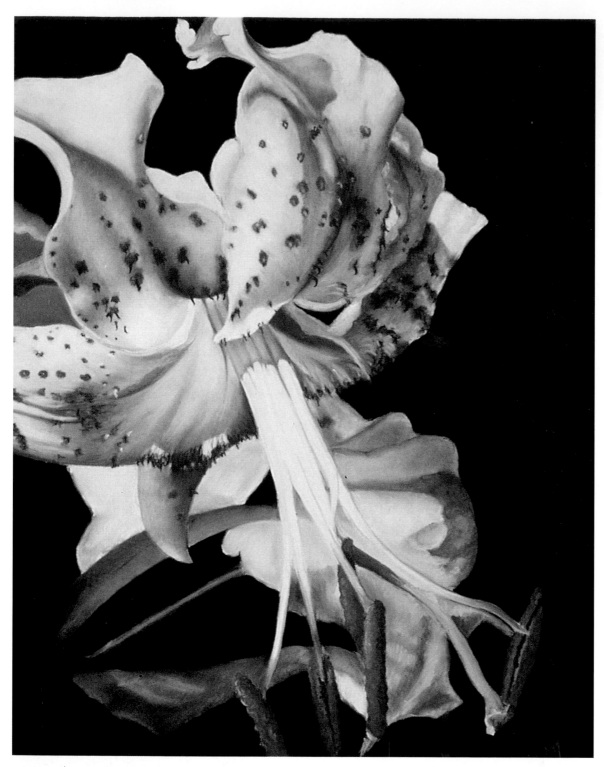

RUBRUM LILY
Mary Beth Koeze, Pastel
31"×37"
(78.7cm×94.0cm)

IDEA #14 | PAINT A FLOWER UP CLOSE TO CAPTURE ITS SUBTLETIES

This artist has not only painted a close-up, but she has also painted the flower on a large scale so all of the wonderful subtleties of its shape and color are more obvious. She adds to the drama by painting a very dark background. This accentuates the light on the flower and shows the wonderful design of the negative space (the space in an artwork not occupied by subject matter).

Stop and Smell the Flowers

Flowers are a never-ending source of pleasure for both the viewer and the painter. Their possibilities are infinite. You can paint a single blossom, a dozen flowers or a meadow full of blooms. You can paint them indoors or outdoors. You can paint them in a vase, on a fence, on a mountainside.

However, because they are so much a part of our lives, we assume we already know what flowers look like and how to paint them. Every flower is different. In fact, every petal is different. The most exciting paintings of flowers occur when the artist approaches each blossom with a fresh sense of wonder.

There seem to be two general approaches to painting florals. The first is to strive for the exact contours and details of the blossoms. The other is to merely suggest a sense of the flower. Either one of these styles can produce some wonderful images.

In addition to considering the appearance of your floral subject, make a painting stronger by thinking about what these flowers mean. Cut flowers often suggest celebration. Potted flowers show the peacefulness of home. Flowers growing wild represent the freedom of nature. Use the emotional nuances of flowers to give your art more intensity.

IDEA	PAINT FLOWERS
#15	FROM A DISTANCE

In this piece the distant flowers blend together to form solid patches of color. This approach works especially well in formal gardens where whole sections have been planted with the same flower.

WISHING WELL, D.A.B.S.
Marian Hirsch, Pastel
20″ × 30″ (50.8cm × 76.2cm)

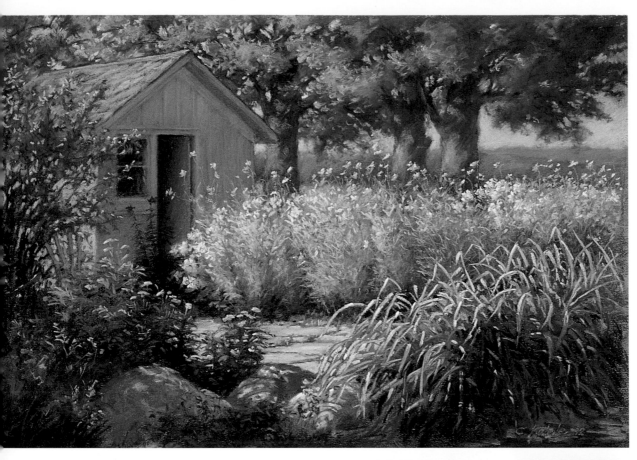

IDEA #16 | PAINT THE VARIETY FOUND IN YOUR BACKYARD

Kuhnle has captured the variety of shapes and textures found in a backyard garden, not only among the flowers, but also in the building, trees and rocks. Notice the different types of strokes she uses, thick and thin, blended and unblended. She creates a sunlit feeling by contrasting the warm sunlit area with the cool shadows.

IDEA #17 | INCLUDE A WORKING GARDENER AMONG THE BEAUTIFUL FLOWERS IN YOUR SCENE

Including a gardener in this scene adds an element of storytelling. The bent-over position of this woman tells what hard work it is to maintain a garden.

BICKLEIGH GARDEN
John Pototschnik, Oil
20" × 18¼" (50.8cm × 46.4cm)

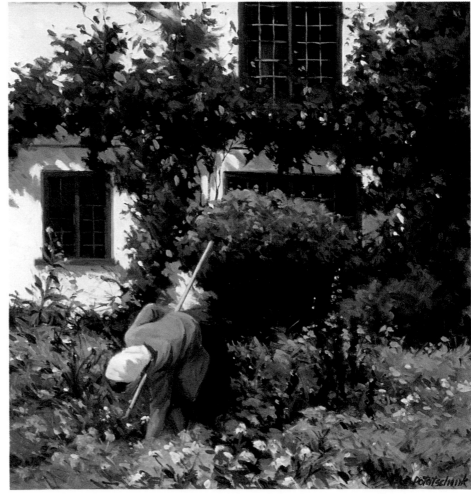

Tips on Painting Flowers

• I know many artists who use artificial flowers, but I find that fresh flowers result in more interesting paintings. Silk and plastic flowers tend to have a sameness in their shapes and colors. Their petals rarely have the delicate translucency of fresh flowers. Of course, fresh cut flowers have the disadvantage of changing with time, opening and then wilting. You can minimize the change by keeping cut flowers in a cool location and providing plenty of water. Florists can provide preservatives to extend the blossoms' life. A small amount of chlorine bleach in the water can revive drooping sunflowers.

• Pay special attention to shapes. Flower contours have all sorts of interesting ins, outs and unexpected angles. Also notice the overall shape of a bouquet when you are planning your composition.

• The petals on a flower are all different. I often see beginning artists paint daisies or sunflowers with the same stroke for each petal, but even the petals of daisies vary in shape and position.

• Most blossoms are composed of many colors. Even though a rose looks pink from a distance, it may actually be comprised of many pinks, reds, yellows, oranges, purples, blues or greens. Don't be afraid to use cool colors and dark colors within your flowers.

• Light on flowers is fascinating because of the translucency of the petals and the arrangement of overlaid petals. Don't ignore the subtleties of value caused by light shining through the petals.

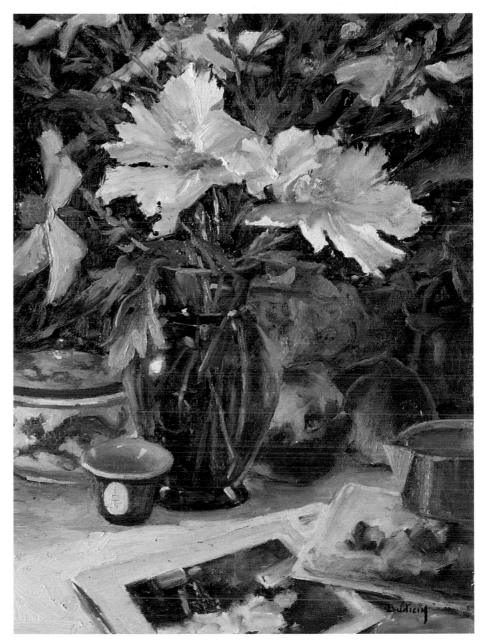

IDEA	PAINT THE OBJECTS AROUND
#18	YOUR ARRANGEMENT

When painting cut flowers in a vase, it is important not only to arrange the flowers but also to arrange the space around them. For this composition, John Budicin includes several objects on the tabletop to make us feel these flowers are part of an everyday life. Notice how he uses color to integrate the flowers into the composition, repeating white and yellow through the painting.

MATILLJA POPPIES
John Budicin, Oil
20" × 14" (50.8cm × 35.6cm)

IDEA #19 | PAINT FLOWERS FROM A SPECIAL OCCASION

BIRTHDAY TULIPS
Carole Katchen, Pastel
12" × 9" (30.5cm × 22.9cm)

Flowers are appropriate gifts for almost any occasion and the type of flowers usually signifies the nature of the event. Flowers for a wedding tend to be grand arrangements. Flowers for Mother's Day are often more delicate. These potted tulips were a simple, thoughtful birthday gift from a friend.

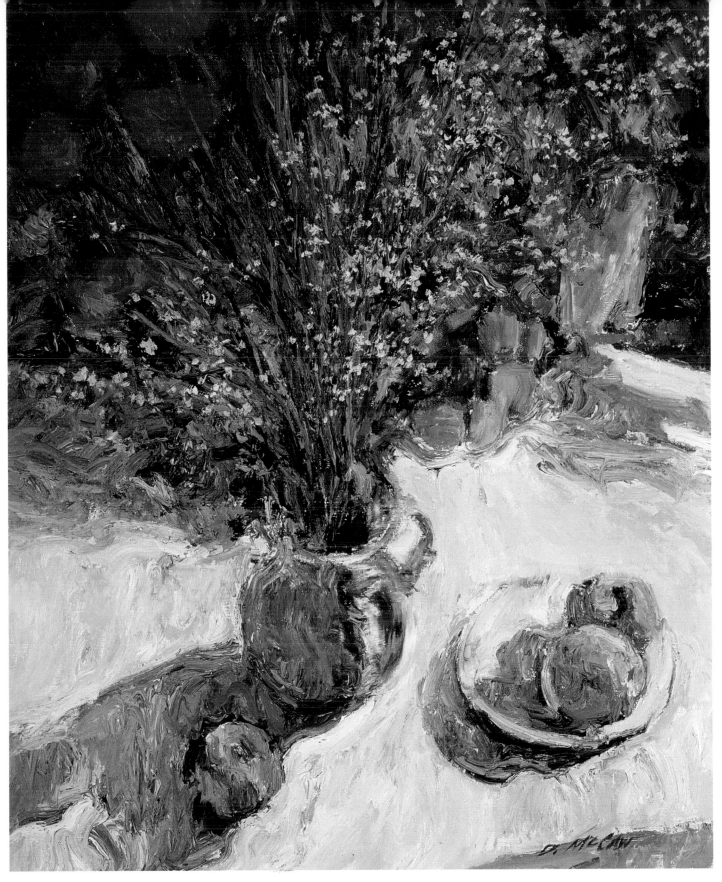

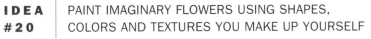

IDEA #20 | PAINT IMAGINARY FLOWERS USING SHAPES, COLORS AND TEXTURES YOU MAKE UP YOURSELF

STILL LIFE
Dan McCaw, Oil
30" × 24" (76.2cm × 61.0cm)

These flowers appear to be real because the shapes, colors and textures resemble real flowers, but they were made up by the artist. These flower shapes can be useful in filling in the design of a still life or interior.

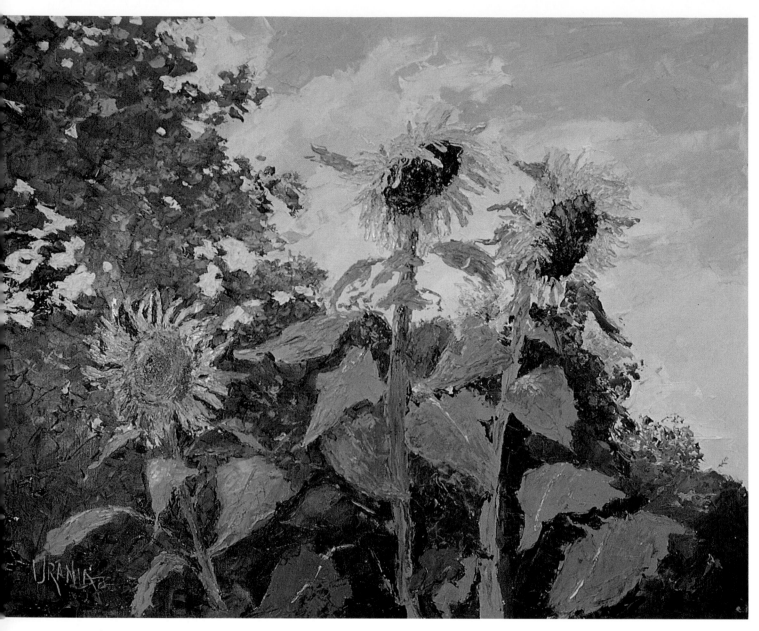

IDEA #21 | PAINT THE WONDERFUL, STATELY PRESENCE OF LARGE FLOWERS

SUNKISSED SUNFLOWERS
Urania Christy Tarbet, Oil
24" × 30" (61.0cm × 76.2cm)

It is impossible to ignore a giant sunflower growing up to the sun. Tarbet made these sunflowers more important by placing them against a simple background. The painting has a limited palette, but Tarbet applies paint with a palette knife to add the lively surface texture, which creates interest.

IDEA #22 | PAINT A PATTERN OF SMALL FLOWERS

MARY'S GARDEN
Connie Kuhnle, Pastel
13" × 18" (33.0cm × 45.7cm)

These small blossoms seem to sparkle as the sun bounces off individual petals. The smallness of the flowers is shown in contrast to the large building. Another wonderful visual contrast is the irregular placement of flowers against the geometric pattern of the fence.

Paint a Varied Bouquet

IDEA #23 | PAINT A VARIETY OF FLOWERS; CONTRAST SHAPES, VALUES, SIZES AND COLORS

The tremendous variety of flowers in nature allows for many different kinds of counterpoint—round against pointy blossoms, light against dark or, as we have here, large roses against clusters of tiny hydrangea blossoms.

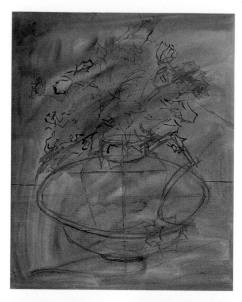

STEP ONE
Wash and Sketch
Urania Christy Tarbet begins by washing loose oil color over the canvas and then brushing on a quick sketch of the composition.

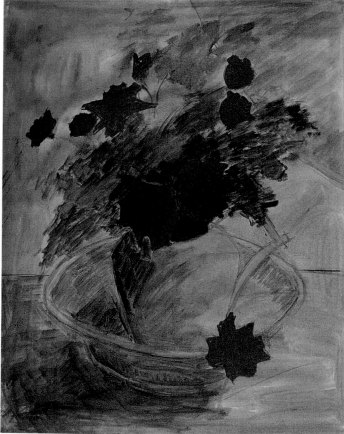

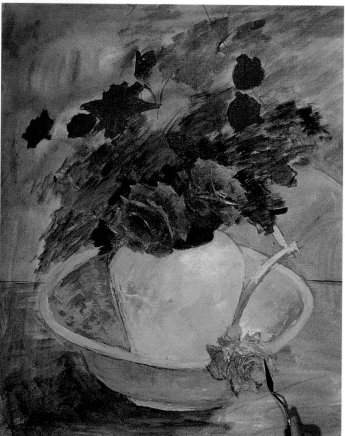

STEP TWO
Block in Colors
Using a brush, Tarbet blocks in colors, shapes and values. Painting with less oil in the first layers of paint and more in the top layers, so expansion or contraction in the lower layer won't crack the surface, she keeps paint application light through this point.

STEP THREE
Model the Forms
Now Tarbet begins to use a palette knife for a thicker application of paint. With bold strokes she models the forms of the individual blossoms and begins to define the pitcher and bowl.

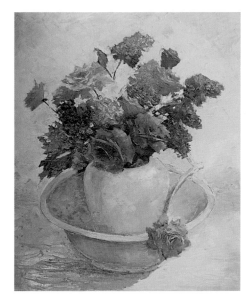

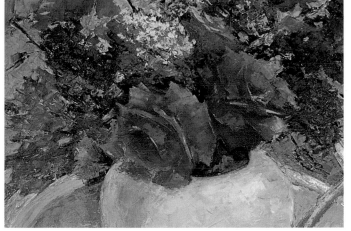

STEP FOUR
Pitcher and Background
Tarbet solidifies the pitcher, then adds a cool, light background to set off the flowers.

Detail
In this close-up you can see how the strokes themselves reflect the structure of the flowers. The strokes of the rose petals are larger and flatter than those of the hydrangea blossoms, which are suggested with tiny, choppy strokes of the palette knife.

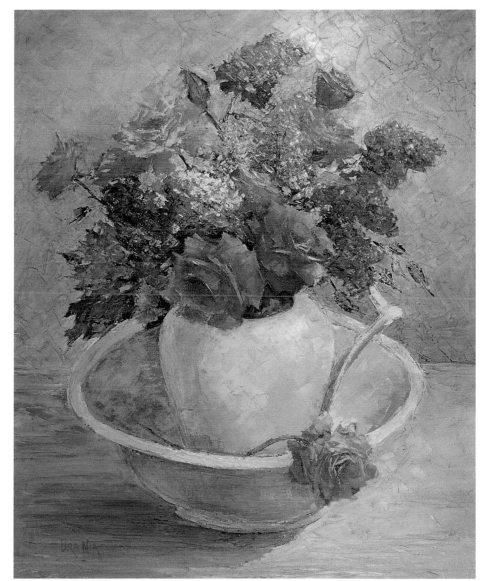

STEP FIVE
Finish With Accents
Tarbet finishes the painting by intensifying the background and shadows with a cool blue green. She includes some of the same color as accents within the flowers and foliage for color harmony.

VICTORIAN BOUQUET
Urania Christy Tarbet, Oil
30" × 24" (76.2cm × 61.0cm)

IDEA #24 | PAINT A SIMPLE ARRANGEMENT OF CUT WILDFLOWERS

Wildflowers seem romantic when cut and put in a glass. Young's understated watercolor shows the charm of these simple daisies. Notice that she has defined the flowers by painting the negative space around them.

CALIFORNIA SUNSHINE
Robin Young, Watercolor
20" × 14" (50.8cm × 35.6cm)

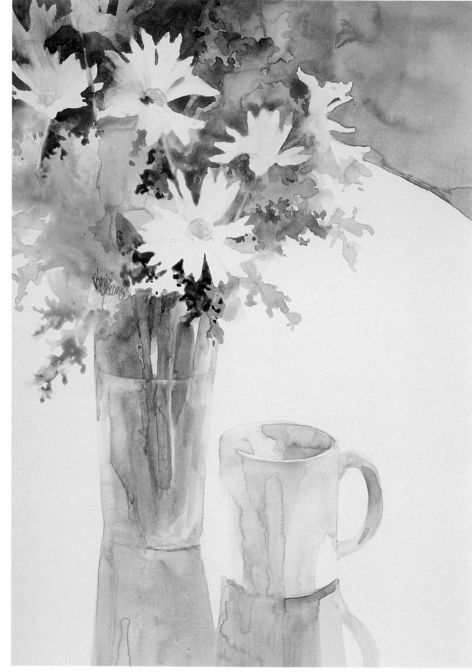

IDEA #25 | LET FLOWERS SUGGEST EMOTIONS OR SITUATIONS

When I saw these cactus blooming along a roadside in Arizona, they made me think of brides with wreaths and bouquets. I painted them in a cluster with that in mind.

DESERT BRIDES
Carole Katchen, Pastel
20½" × 15½" (52.1cm × 39.4cm)

More Fresh Ideas

IDEA #26 | PLANT AN AMARYLLIS BULB IN A POT

Complete a painting at each stage of its growth, from the first tiny green sprout to the final lush blossoms.

IDEA #27 | PAINT AN ARRANGEMENT OF DRIED FLOWERS

As flowers dry, their shapes generally become more angular and the colors more subtle. To dry a bunch of flowers, tie the bottoms of the stems and hang them upside down.

BLOOMING MEADOW
Pat Pendleton, Oil Pastel
32½" × 39½" (82.6cm × 100.3cm)

IDEA	PAINT WILDFLOWERS IN THEIR
#28	NATURAL SETTING

There is always an element of the unexpected about wild-flowers, which is one of the things that makes them seem so special. A successful wildflower painting conveys a bit of that surprise or wonder that we feel when we find them in nature. This profusion of wildflowers makes a statement about the abundance of nature. When painting an entire field of flowers, divide the composition into a few main shapes and pick out one or a few objects to emphasize as your focal point, here the large flowers in the foreground.

IDEA	EXPERIMENT WITH
#29	CONTRASTS

The intensely dark shadows behind these sunlit roses make us feel the flowers have come out of hiding. The cool green provides a vibrant contrast to its complementary pink in the flowers.

WILD ROSES
Kathleen Kalinowski, Pastel
18" × 23" (45.7cm × 58.4cm)

Master Still Lifes

A still life is just a grouping of objects; even if the individual items are boring by themselves, what makes a good still-life painting is the way those objects are arranged and lit. Pick several items that look good together, either in harmony or by contrast, and you have a successful still life. Of course, the technical skill of the artist also makes for a powerful painting, because the most mundane object becomes magical when it is painted brilliantly.

When you set up a still life, there are two components to consider: 1) how it looks, and 2) what it means. The look of a still life depends on all the abstract design elements important to any painting. How do the colors relate to each other? Do the shapes and sizes of the objects fit together to make an interesting design? Are they placed in such a way that they lead the eye around the painting? Is there enough variation in size, value and texture to provide visual interest?

The meaning of a still life refers to the intellect and emotions it conveys.

A concept or feeling can be what holds a group of objects together. Do the objects make sense together? What do they remind you of? How do they make you feel? Happy? Nostalgic? Melancholy?

The best way to find good subjects for still lifes is to keep your eyes and your mind alert as you pass through your day. Consider every object and every grouping of objects as a potential still-life subject. Eventually you will find those most appealing and intriguing for you.

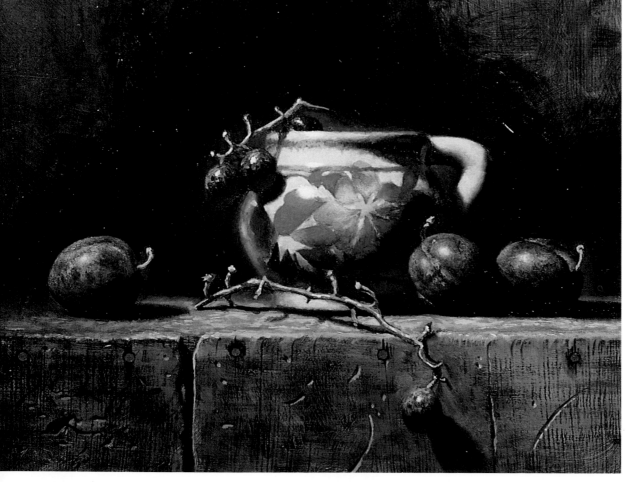

PRUNE PLUMS
Jeff Legg, Oil
8" × 10"
(20.3cm × 25.4cm)

IDEA #30 | CHOOSE OBJECTS THAT REPEAT THE SAME COLOR

Repeating a color gives the painting a natural harmony, even if the objects wouldn't otherwise fit together. The plums, grapes and bowl all contain the same blue, making us think they all fit together, whether or not there is a reason for the combination.

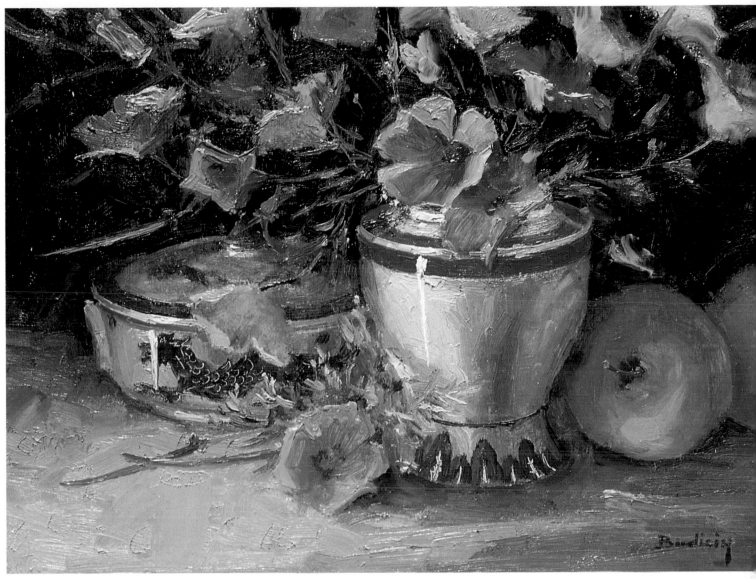

The overall color of this painting is yellow. The poppies, fruit, tabletop and reflections on the ceramics—all are yellow, gold and orange. The resulting feel of the painting is very warm.

POPPIES IN DELFTWARE
John Budicin, Oil
9" × 12" (22.9cm × 30.5cm)

IDEA #31 | ARRANGE YOUR STILL LIFE ON AN INTERESTING PIECE OF FURNITURE

This bookcase provides a natural division of shapes. The open door and hanging wreath break up the cold geometry of the composition, making it feel more human. The choice of objects in the painting makes the viewer wonder about the person who lives there, thus becoming more involved with the art.

SHELVES
Lydia Martin, Oil
50" × 36" (127.0cm × 91.44cm)

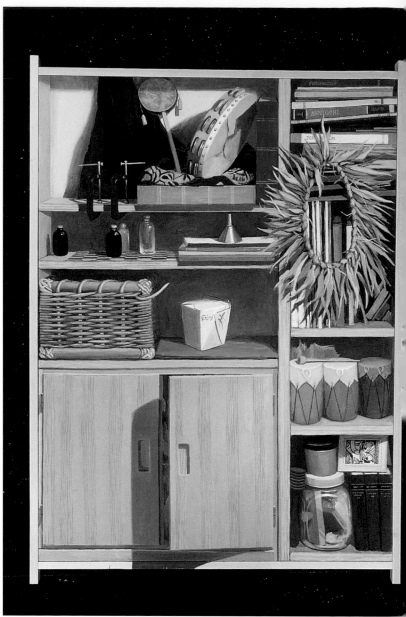

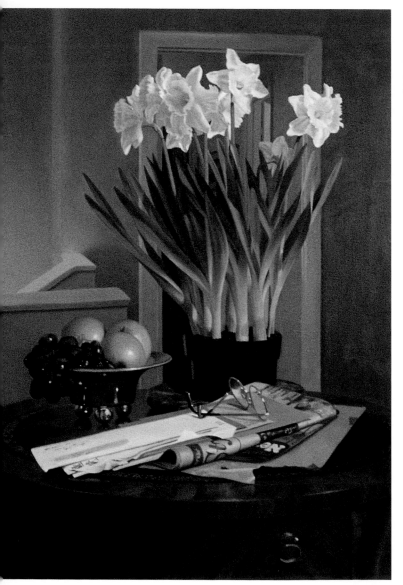

IDEA #32 | FIND A NATURAL GROUPING OF EVERYDAY OBJECTS FROM YOUR OWN LIFE

As you walk around your home, look at the things that surround you. The objects of your life tend to fall into natural groups, many of which make engaging still-life subjects. This artist chose objects on a hall table—mail, newspaper, glasses, fruit and a potted plant. The meticulous realism of this painting makes the everyday objects seem more important. Careful attention to highlights and reflections makes everything look polished and well cared for.

ONE O'CLOCK POST
Sharon Moody, Oil
30" × 22" (76.2cm × 55.9cm)

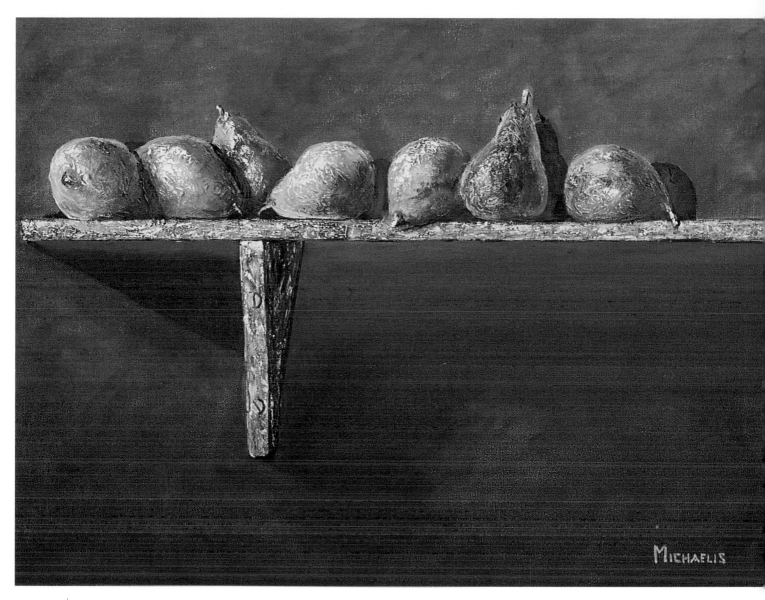

IDEA #33 | PAINT OBJECTS IN VIBRANT COMPLEMENTARY COLORS

By placing the green pears and shelf against a red wall, Michaelis has established the vibrancy of complementary colors (those opposite each other on the color wheel). Whenever you place red next to green, yellow next to purple or blue next to orange, you make each color seem brighter than it would appear by itself.

SEVEN PEARS
R.L. Michaelis, Oil
18" × 24" (45.7cm × 61.0cm)

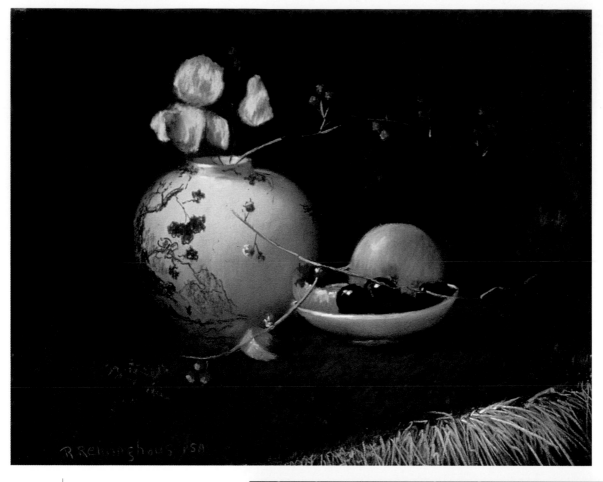

CHING VASE &
SILVER
DOLLARS
Ruth Reininghaus, Oil
11" × 14"
(27.9cm × 35.6cm)

IDEA #34 | COMPOSE A UNIFIED STILL LIFE WITH A VARIETY OF ROUND OBJECTS

The objects in this painting are light and dark; large and small; orange, purple, white and red. Yet the composition has a comfortable unity because so many of them are round in shape.

IDEA #35 | USE A WONDERFULLY ODD-SHAPED OBJECT AS THE FOCAL POINT OF YOUR PAINTING

Look at the shape of the exotic pitcher in this painting. With its bold points and curves, it holds the viewer's attention, just as an abstract shape. Surrounded by the more mundane forms of fruit and fabric, it serves as a visual anchor for this artist's classical still life.

TIBETAN COPPER
Ruth Reininghaus, Pastel
12" × 16" (30.5cm × 40.6cm)

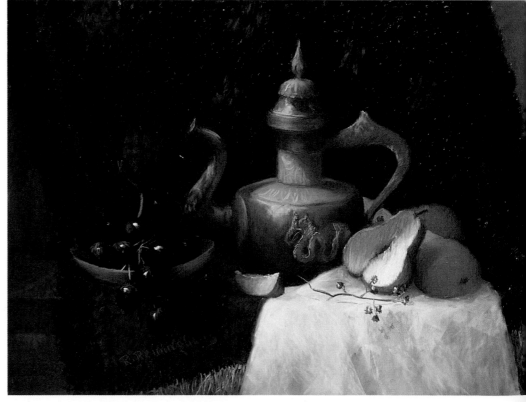

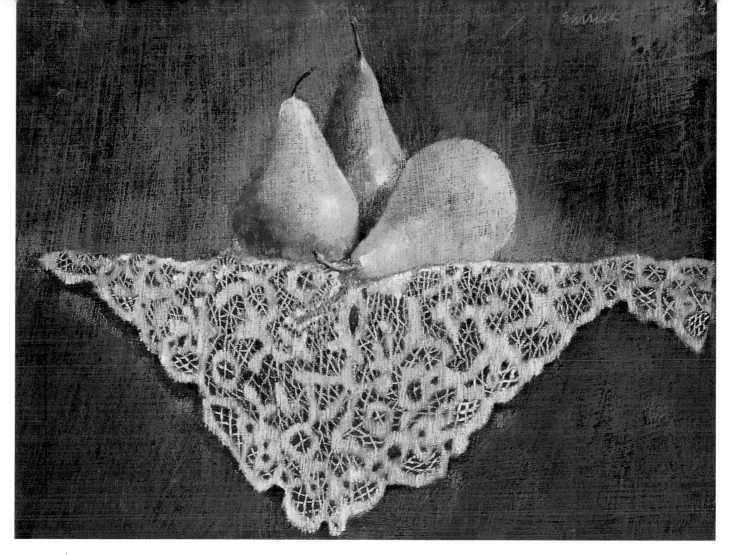

IDEA #36 | COMPOSE A STILL-LIFE PAINTING WITH DYNAMIC TRIANGLES

This painting is composed of several triangles: the pears individually and together, the triangles of lace. Notice how the large shapes of the lace and pears balance each other. The small triangle of lace off to the right side keeps the painting from being too symmetrical.

THREE PEARS/CHEMICAL LACE
Lilienne Emrich, Pastel
25" × 23" (63.5cm × 58.4cm)

IDEA #37 | COMBINE VERY DIFFERENT SHAPES

What makes this painting interesting is its contrasts. A bowl of olives and a book about bugs have very little to do with one another. Even their shapes are drastically different. What unifies the painting is the meticulous attention to detail throughout.

OLIVES WITH BUG BOOK
Butler Steltemeier, Watercolor
15" × 24" (38.1cm × 61.0cm)

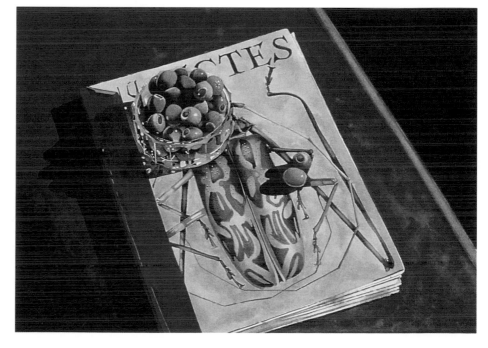

When a painting consists of a small number of objects, each one must have a lot of visual interest on its own. In this piece the lace is fascinating because of the intricate pattern. The pears hold our attention because of the intense color and dramatic lighting.

RED PEARS & EUROPEAN LACE
Lilienne Emrich, Pastel
27" × 30" (68.6cm × 76.2cm)

Tips on Painting Still Lifes

• Choose objects you like. If you're bored by the objects, it will be difficult for you to give them the attention they deserve.

• Choose one dominant object to be your focal point. Everything else should relate to that object.

• Once you've chosen several possible objects, try them in a variety of positions. See how the colors and shapes relate to one another.

• Light can greatly enhance or alter a still life. Try out different kinds of lighting: a single light source, flat lighting, colored light, dim lighting; light from above, below or one side. Use highlights and shadows as a dynamic part of your design.

• Take your time. The most important part of painting a still life occurs before you pick up a brush—looking at what is there. Look. Study. Don't assume you already know what the objects look like.

• Here are some suggestions for seasonal still-life subjects:

• Summer flowers, gardening tools, beach toys, sunglasses, iced drinks, sandals, outdoor sports equipment or picnic supplies painted with bright colors.

• Autumn leaves, rake, football paraphernalia, school supplies, pumpkins, dried corn, Halloween costumes or Thanksgiving ornaments painted with warm earth colors.

• Winter mittens, ice skates, sleds, fireplaces, potbellied stoves, Christmas decorations, New Year's horns or confetti painted with whites and blues for a cool look.

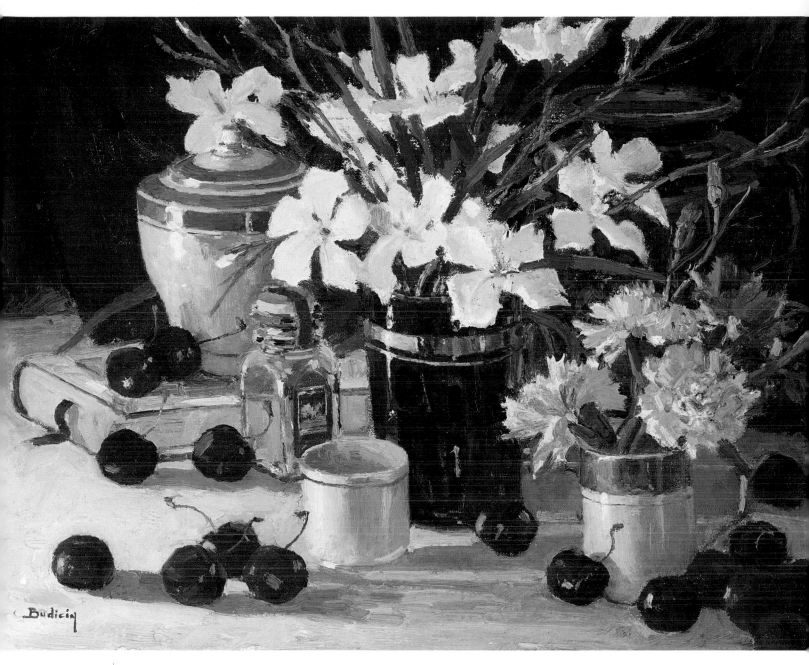

IDEA #39 | PAINT A COMPOSITION WITH MORE THAN TEN OBJECTS

When you combine a large number of objects, the challenge is to keep the composition from looking jumbled. What keeps this composition from being chaotic is the grouping of objects into a lighter area, the upper left, and a darker area, the lower right. Repetition of color helps provide harmony. The scattering of cherries through much of the painting also adds unity.

SUMMER ARRANGEMENT
John Budicin, Oil
14" × 18" (35.6cm × 45.7cm)

IDEA #40 COMBINE UNEXPECTED MECHANICAL AND ORGANIC ELEMENTS

Some of the most interesting still lifes are created by combining unrelated or unexpected elements. The functional watercooler is such a different element from the vase of flowers that it makes the viewer wonder why they are placed together. The colors and shapes are also different. The three transparent containers of water in the center of the composition provide the element of unity.

WATER COOLER
Jerald Silva, Watercolor
45" × 25" (114.3cm × 63.5cm)

IDEA #41 COMBINE ANIMAL, VEGETABLE AND MINERAL

A ceramic horse, onions and a wine glass have no apparent connection. Legg makes the combination work by providing a single, dramatic light source and painting all the objects in warm, earthy colors. His classical rendering and attention to detail provide additional harmony.

STILL LIFE WITH TANG HORSE
Jeff Legg, Oil
24" × 24" (61.0cm × 61.0cm)

**IDEA
#42** | ADD VARIETY TO OBJECTS OF THE SAME
TYPE, SHAPE OR COLOR

When most of the objects in a still life are the same shape or color, the challenge
is to add a sense of variety. I made these pots seem more interesting by turning
some of them upside down, using some that were empty and some planted,
and including one that was green plastic rather than red clay.

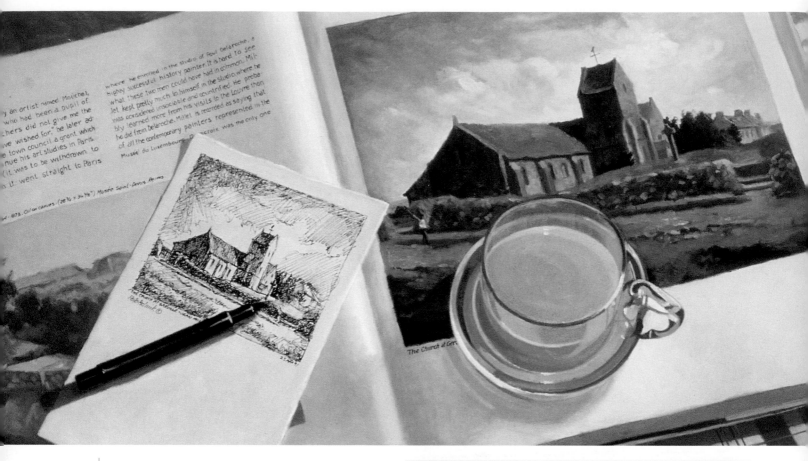

IDEA #43 | PAINT OBJECTS THAT PORTRAY A MOMENT IN YOUR EVERYDAY LIFE

A combination of objects like this is intriguing because it reveals an intimate moment. We see an art book, a sketch and a cup of tea; somehow we are present in the artist's studio.

MASTER SERIES #1—MILLET
John Pototschnik, Oil
12"×24" (30.5cm×61.0cm)

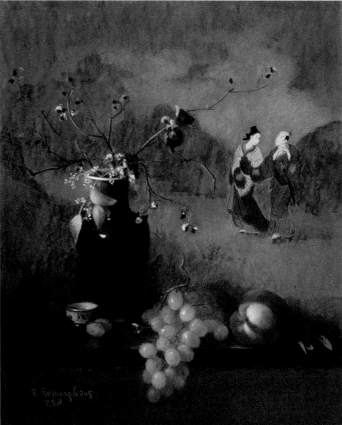

IDEA #44 | PAINT STILL-LIFE OBJECTS FROM A PLACE YOU'VE TRAVELED OR WOULD LIKE TO VISIT

This oriental vase, screen and cup reveal Reininghaus' fascination with Asia. Create a still life with souvenirs of your own. You might include postcards or snapshots to underline the experience of travel.

K'ANG-HSI VASE
Ruth Reininghaus, Pastel
14"×18" (35.6cm×45.7cm)

IDEA #45 | CHOOSE OBJECTS THAT REPRESENT A SEASON OF THE YEAR

PROMISE OF SPRING
Carole Katchen, Pastel
19" × 25" (48.3cm × 63.5cm)

The choice of spring flowers gives the main clue to the time of year this painting represents. The mood of spring is in the choice and treatment of colors—soft pastel tones, yellows, pinks, violets—that are associated with crocus and Easter baskets. The application of pigment is also soft and gentle, like springtime.

More Great Ideas

IDEA #46 | CHOOSE THREE OBJECTS FROM YOUR CHILDHOOD

A concept or feeling can be what holds a group of objects together.

IDEA #47 | FIND OBJECTS THAT REPRESENT SOMEONE YOU LOVE

Find a combination that gives a glimpse into who that person is.

IDEA #48 | COMBINE OBJECTS THAT ARE ELEGANT

Create an intriguing image by using elegant elements as the basis of a painting.

IDEA #49 | COMBINE OBJECTS THAT MAKE YOU LAUGH

Remember, when you choose these items for a still life, they must also work together in terms of abstract painting components. Are the colors compatible? Do the shapes fit together to make an interesting design? Is there enough variation in size, value and texture to provide visual interest?

IDEA #50 | COMBINE OBJECTS THAT ARE USEFUL

Turn a mundane subject into an exciting painting.

IDEA #51 | PUT LIGHT OBJECTS AGAINST A DARK BACKGROUND

In still lifes, as in all other paintings, the foundation of a composition is value. Is there enough light and dark variation to make the image interesting? In this piece the three white objects provide a striking contrast with the dark background. The white seems even brighter because of the reflective quality of the surfaces.

BAVARIAN PORCELAIN & CRAB APPLES
Ruth Reininghaus, Oil
14" × 18"
(35.6cm × 45.7cm)

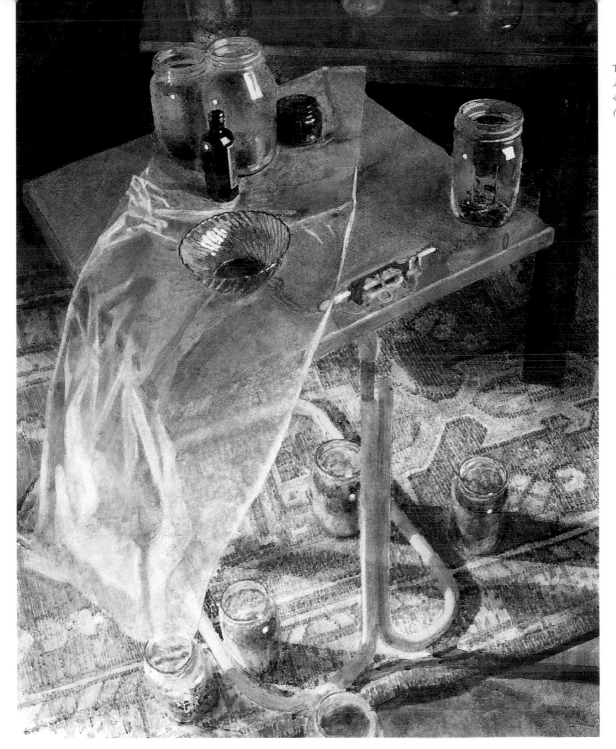

TOO MANY JARS
Jerald Silva, Watercolor
44" × 34"
(111.8cm × 86.4cm)

IDEA #52 | PAINT THE CHALLENGING COLORS, VALUES AND REFLECTIONS OF TRANSPARENT OBJECTS AND WHAT'S BEHIND THEM

For an intriguing technical project, include a transparent object in your still life. Here Silva shows his virtuosity by painting not only an assortment of glass pieces, but also including the long strip of plastic. The challenges are multiple. How does the transparent material alter the color and value of what is behind it? What lights and colors does the surface of each object reflect? What shadows, colors and highlights does each object project? When tackling such a complex subject, allow yourself a lot of time for just looking at the subject. Let your eye wander over the setup, searching for all the subtle nuances of light and color.

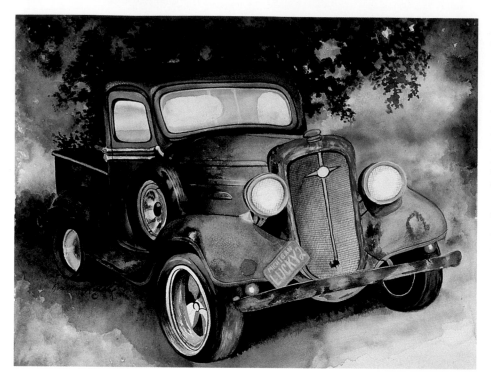

IDEA #53 | EVOKE A SENTIMENTAL FEELING WITH AN OLD MACHINE RELIC

A rusty old machine can evoke a sense of nostalgia, especially an interesting vehicle like this classic truck. Redding has painted it in a whimsical style, and added to the character of the scene by placing the truck in the shade of a tree, as if it is resting in retirement.

TRUCKIN' TWO
Rose Marie Redding, Watercolor
18" × 22" (45.7cm × 55.9cm)

Find the Spirit in Machines

Some people would never think of painting a machine. It doesn't seem artistic somehow. Yet machines can be wonderful subjects for art.

Machines make something happen. So when you put a machine into a painting, it adds a component of storytelling. Something did happen, is happening or will happen. Machines also imply the presence of people. Whether or not there's a person visible in the composition, it has a human element.

Perhaps most important, machines are interesting to look at. They have hard edges and sharp angles. They have intricate parts that fit neatly together. They look geometric, solid, permanent. They do serious work, and some look quite impressive.

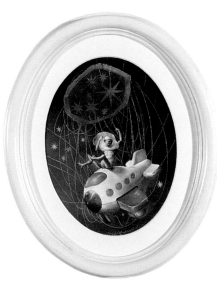

THE STAR PLANTER
Renzo Galardini, Oil
9¼" × 7¼"
(23.5cm × 18.4cm)

IDEA #54 | PAINT A MACHINE THAT'S FUN

This Italian surrealist has used a toy airplane and parachute in his playful composition. He painted the toy plane with solid form and weight as a counterpoint to the airborne parachute. The somberly painted figure provides a thought-provoking contrast to the brightly painted playthings.

Tips on Painting Machines

• When choosing a machine to paint, look at both the total shape and the shapes of the various parts. A close-up segment of the machine or tool often has a fascinating design.

• The materials from which a machine is made give it personality. Is the metal slick and new? Or pitted and rusty? Is the plastic shiny, transparent, translucent? Is the paint smooth or peeling? Look for interesting textures.

• Is the machine large or small? Give a sense of its size by painting it with something to show its scale.

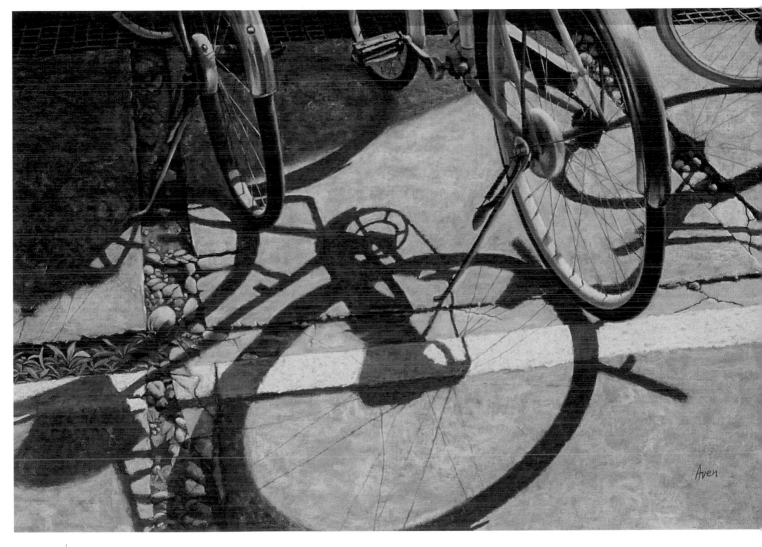

IDEA #55 | PAINT THE COMPELLING CAST SHADOWS OF A MACHINE

THE SHADOW
Aven Chen, Pastel
24" × 36" (61.0cm × 91.4cm)

Because of their geometric forms and intricate connections, machines often cast wonderful shadows. These bicycles are a great example. The interwoven lines of the bicycle tires and their cast shadows create a fascinating abstract pattern. Seeing the shadow of an object in a painting can often be more compelling than seeing the object itself.

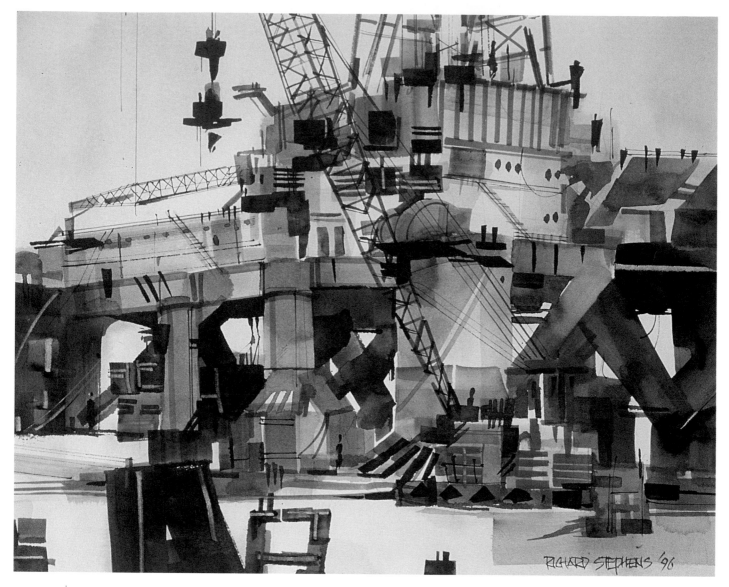

IDEA #56 | ISOLATE PART OF A MACHINE AND FOCUS ON ITS DETAILS

OIL RIG
Richard Stephens, Watercolor
21" × 23½" (53.3cm × 60.1cm)

Rather than trying to paint an oil rig in its entirety, Stephens has selected one part and focused on the details within it. Any successful painting should work as a pure abstract composition. Look at the fascinating arrangement of parallel lines, squares and rectangles that comprise this image. If you turn the painting on its side or upside down, the composition still works.

IDEA #57 | PAINT THE NOSTALGIA OF FARM IMPLEMENTS

Because so many people live in urban environments today, farm machinery has taken on a nostalgic connotation. This old tractor seems charming, even though it's a heavy piece of metal equipment. Notice the sharp-edged strokes Stephens used to enhance the mechanical nature of his subject.

RETIRED FARMER
Richard Stephens, Watercolor
13½″ × 10″ (34.3cm × 25.4cm)

IDEA #58 | PAINT A MUSICAL INSTRUMENT

Musical instruments work well in paintings because they have wonderful shapes. Here the long, thin form of the saxophone is echoed in the physique of the musician. Because I was painting on location, with time constraints and a moving subject, I focused on the large shapes and ignored most of the details.

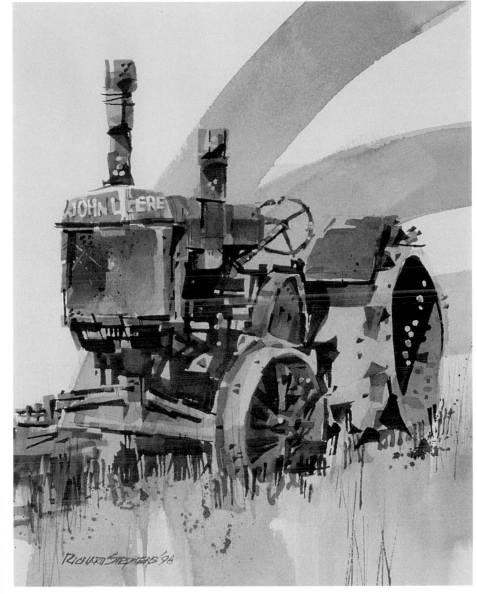

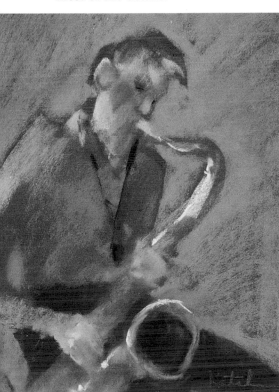

SAX IN THE AFTERNOON
Carole Katchen, Pastel
12″ × 9″ (30.5cm × 22.9cm)

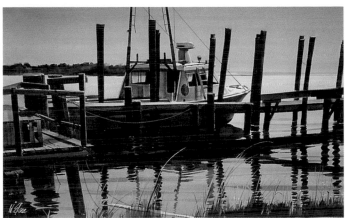

MOORING AT SEABROOK
Wilbur Elsea
Watercolor
16″ × 22″
(40.6cm × 55.9cm)

IDEA #59 | CONVEY A SENSE OF STILLNESS BY PAINTING A FAST-MOVING VEHICLE AT REST

This scene looks even more peaceful because of the idyllic setting. Notice how Elsea uses a geometric composition, which further enhances the mechanical feel of the boat.

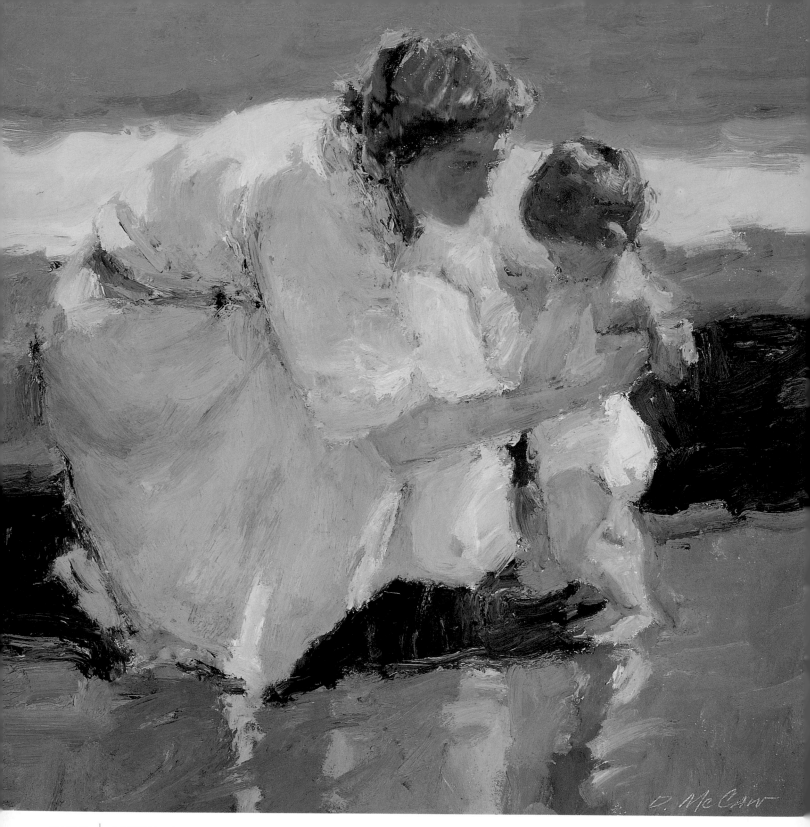

IDEA #60 | CREATE A WARM, SENTIMENTAL MOOD BY PAINTING A MOTHER AND CHILD

HELPING HAND
Dan McCaw, Oil
20" × 20" (50.8cm × 50.8cm)

The graceful figures of mothers with babies make great subjects; the big pitfall is that many such paintings are merely sentimental. Develop this subject with the same rigorous attention to technique you would apply to any other subject. McCaw's paintings of women with children show how the use of light, color and stroke are just as important to the artist as the heartwarming subject.

Paint All Kinds of People

My favorite subjects are people; they constantly inspire me. In addition to being visually interesting, they move and express emotion.

Some artists get so involved capturing the many characteristics of their human subjects that they forget about the abstract elements of good composition. Yes, you want to show what the model looks like and how he or she feels; but don't lose sight of design considerations along the way. Don't forget to be a painter.

Those very design elements are what can draw attention to this particular person. How you place the figure on the canvas, what colors you use, the lighting and surface texture—all of these add significantly to the visual statement you make about your subject.

With people, you have infinite choices of backgrounds, costumes and props. Let all the elements support each other. That is how you create compelling paintings of people.

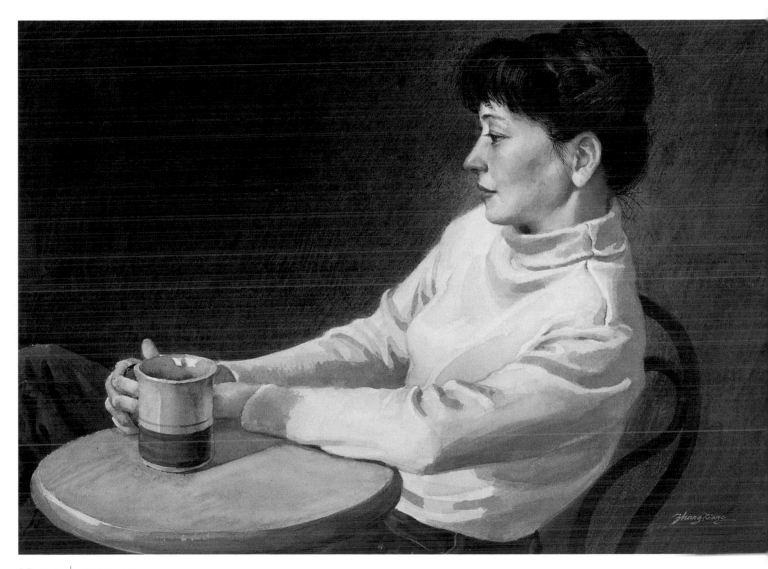

IDEA	PAINT AN
#61	INFORMAL PORTRAIT

A CUP OF COFFEE
Xiang Zhang, Watercolor
15" × 21" (38.1cm × 53.3cm)

This artist was able to create a lifelike image by working from the live model in several sessions. One of the advantages of painting close relatives is that they are more likely to sit for free until the painting is finished. By painting the model from the side, looking away from the viewer, Zhang kept the piece from looking like a formal portrait.

Tips on Painting Friends and Relatives

Throughout art history artists have painted friends and relatives. Besides being the people you care most about, they are usually more readily available to you than other models and are often willing to pose for free. Here are some suggestions for painting your nearest and dearest.

• Explain why you want people to model, and describe what you intend to do. If they understand the painting process, they will be happier to participate.

• Be considerate of time and comfort. Modeling is hard work. If your model is holding one long pose, provide frequent breaks. Use comfortable chairs; add cushions for comfort. Provide a space heater or fan if the temperature in your studio is uncomfortable.

• Look at your model with a stranger's eyes to get a new, clearer view. When you are very familiar with someone, you tend not to see what they really look like. Your vision is influenced by how you feel about them and how they looked in the past.

• Tell them frequently how much you appreciate their effort.

| **IDEA #62** | PAINT A SPECIAL FAMILY MEMBER IN A TYPICAL SITUATION |

MY MOTHER
Anatoly Dverin, Pastel
19" × 17"
(48.3cm × 43.2cm)

What makes this painting so special, and why viewers can relate to it, is that Dverin painted his mother as a real person during a typical moment in her life.

IDEA #63 | PAINT YOUR CHILD AS MORE THAN JUST A CUTE KID

HERE TODAY, GROWN TOMORROW
Connie Kuhnle, Pastel
18" × 24" (45.7cm × 61.0cm)

Kids and puppies are naturally cute, so it's difficult for paintings of them to be considered serious art. This artist is successful because she approaches the child as a real person rather than just a cute kid. Showing him engrossed in an activity gives the piece more depth.

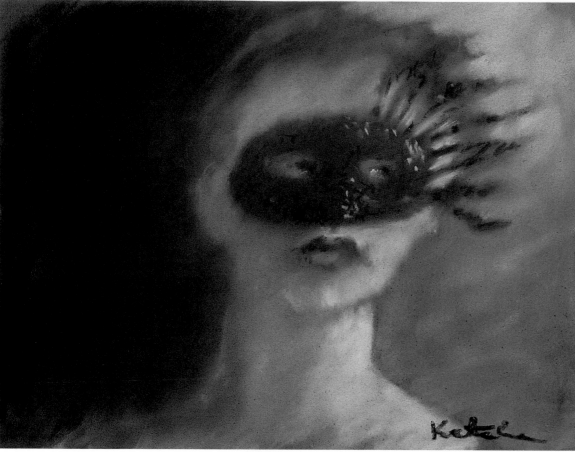

MARDI GRAS
Carole Katchen, Pastel
9" × 12"
(22.9cm × 30.5cm)

IDEA #64 | PAINT AN INTERESTING FACE

Focusing on just the head and neck of this model, I was able to accomplish several things: accentuating expression, creating a simple, bold composition, and suggesting tension in the body as it shows up in the neck. I created color balance by repeating the purple from the left background on the right side of the mask and the blue from the right background in accents on the skin and mask.

IDEA #65 | PAINT PEOPLE FROM A DISTANCE

From a distance you can show the full figures and reveal their body language. You can show where they are and what they are doing. The further away you are, the less intimate the painting will feel; so choose a subject that will benefit from both physical and emotional distance.

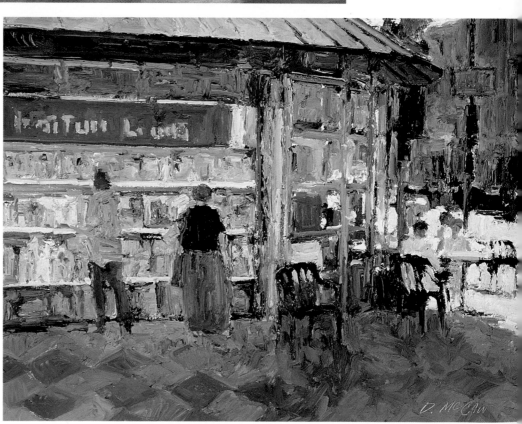

NEWSSTAND CORNER
Dan McCaw, Oil
16" × 25" (40.6cm × 63.5cm)

Tips on Painting People in Public

Drawing strangers in public is a great source of reference material, but it can be tricky for many reasons. Here are some tips to make it easier.

• Use quick and convenient drawing materials. Pen and ink, pencil and wash drawings are most successful for me.

• Find a comfortable place to sit or stand.

• Don't try to capture everything. Look for the *gesture* of the body rather than the anatomy. Find a few details that convey expression rather than trying for the entire face.

• Look for characteristic gestures or poses. A person often returns to one position, giving you several chances to develop that pose.

• If you want to do a more detailed study of a stranger, ask permission. They might say no, but they might also be willing to hold a pose until you complete your sketch.

• Make written notes to help remind you of colors or details.

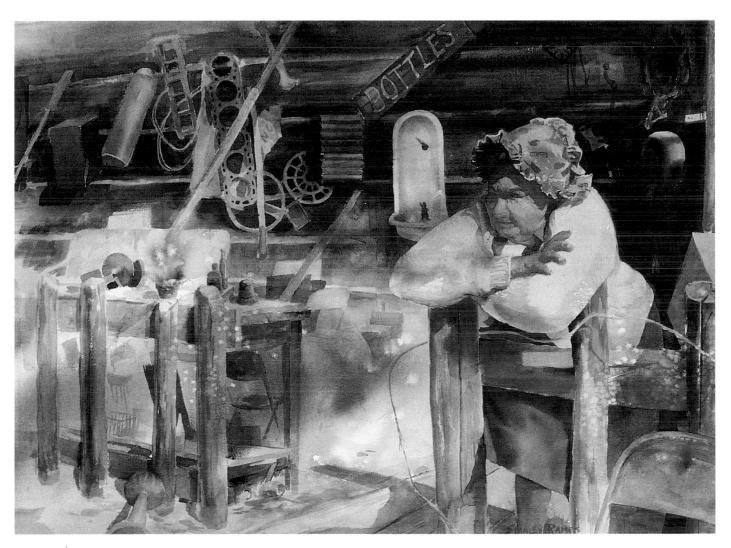

IDEA #66 | ASK FOR PERMISSION TO PAINT A STRANGER

GRANNY MESSANGER
Stanley Rames, Watercolor
22" × 30" (55.9cm × 76.2cm)

Rames says that many artists had tried to paint this old woman and her flea market display; she drove them off at gunpoint. Rames says the difference with him is that he took the time to talk with her and get to know her first. Then he asked her permission to do a painting. Treat your models with respect, whether you know them or not.

IDEA #67 | PAINT A BATHER

This is a natural way of depicting a nude figure. Here McCaw follows in the tradition of Edgar Degas (French, 1834–1917) and the many other painters who depicted women at their baths. McCaw has given his figure a sense of innocence by cocooning the young woman in the tub. He has also eliminated all detail except what's absolutely necessary to define the situation.

THE BATHER
Dan McCaw, Oil
14" × 16" (35.6cm × 40.6cm)

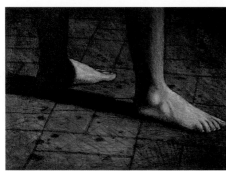

FEET
Warren Criswell
Charcoal/Pastel/Acrylic
18" × 24"
(45.7cm × 61.0cm)

IDEA #68 | PAINT A PART OF A FIGURE OTHER THAN THE FACE

Feet express a great deal about the person standing on them. Pay attention to placement in terms of angle and distance from each other.

IDEA #69 | PAINT A GLIMPSE INSIDE THE ARTIST'S STUDIO

This view of models relaxing may be much more interesting than figures in a more formal pose. One thing that makes Silva's nudes so powerful is that he shows his concern for them as personalities.

TWO MODELS WITH THEIR MOTHER
Jerald Silva, Watercolor
66" × 50" (167.6cm × 127.0cm)

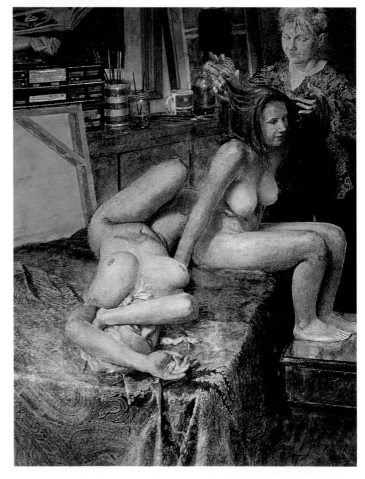

Tips on Painting Nudes

• When painting a nude, remember the model is a person as well as a body. That may seem obvious, but many artists paint nude figures as if the body were one more lifeless object in a still life.

• Every body is unique. Look for the particular characteristics of the model you are painting.

• Look for poses that are natural and comfortable for the model.

• Consider male as well as female figure models.

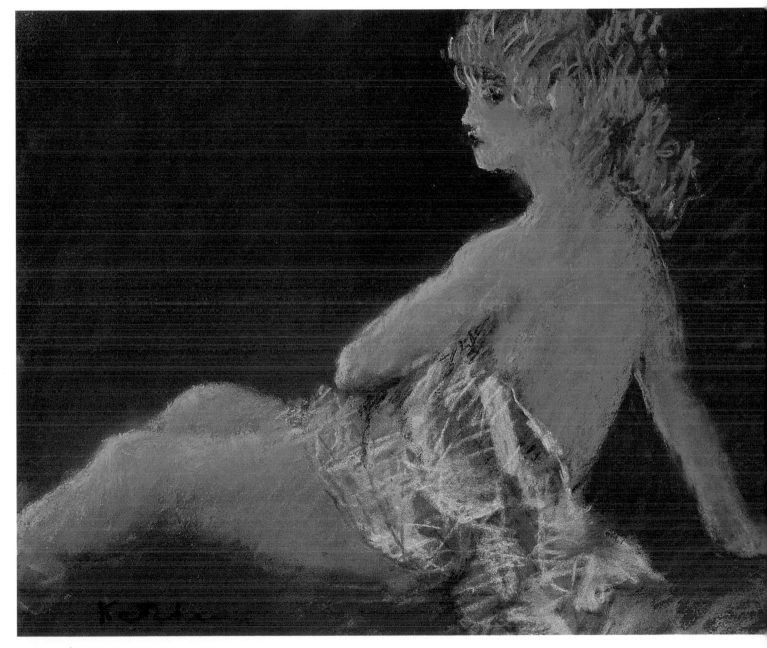

IDEA #70 | PAINT A FIGURE PARTIALLY COVERED BY A DRAPE

LYNN ANN'S NUDE
Carole Katchen, Pastel
9" × 12" (22.9cm × 30.5cm)

Fabric provides a textural contrast with skin. When painting nudes, I generally try to show the model's face. This makes the subject a person, not just a body.

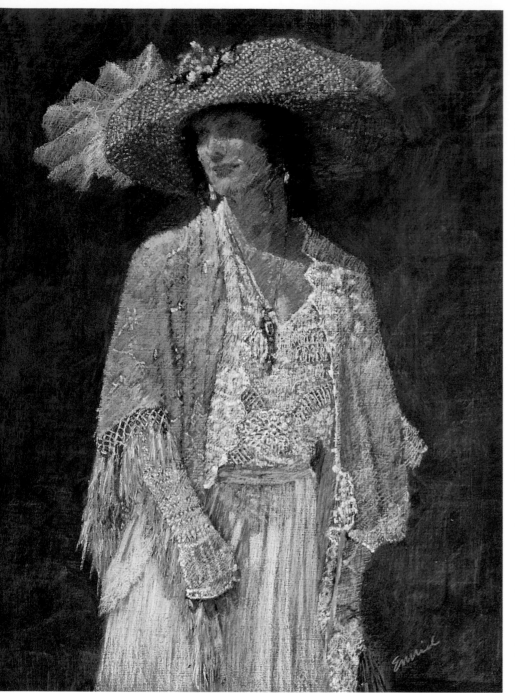

IDEA #72 | PAINT FIGURES IN SILHOUETTE

Lighting figures from behind eliminates the detail and allows you to compose with their abstract shapes. The body language becomes more important because there are no features to reveal expression. Making the people smaller than another element, like the rose in this painting, creates dynamic tension. The viewer's eye automatically goes to the people; then it is drawn back by the larger shape in the foreground.

THE PROMISE
Carole Katchen, Pastel
12" × 9" (30.5cm × 22.9cm)

IDEA #71 | DRESS A MODEL IN A WONDERFUL COSTUME

Emrich has enriched this painting by including all the colors and textures of the historical costume. When you paint a figure in clothing of any kind, be sure you establish accurate anatomy underneath. Even if they don't show, the arms, legs and torso should all be proportional.

COSTUMED LADY
Lilienne Emrich, Pastel
27" × 20" (68.6cm × 50.8cm)

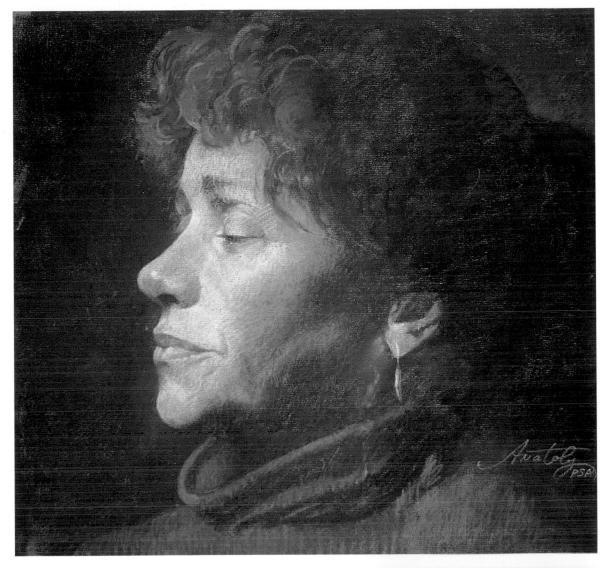

CLEMENTINE
Anatoly Dverin, Pastel
16" × 20"
(40.6cm × 50.8cm)

IDEA | PAINT A FIGURE
#73 | IN PROFILE

Most portraits are painted from the front; it's a refreshing challenge to paint one in profile. Being able to show only one eye and just part of the nose and mouth can be a handicap in conveying expression. Dverin did a masterful job here of overcoming that handicap.

IDEA | PAINT
#74 | YOURSELF

There are infinite variations of self-portraits. Some artists paint themselves at the easel, surrounded by the full paraphernalia of the studio. Some paint themselves partying with friends. Groden has chosen to portray himself here in a simple close-up that focuses the viewer's attention on the artist's expression.

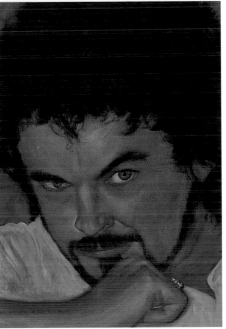

SELF PORTRAIT
Randy Groden, Oil
36" × 24"
(91.4cm × 61.0cm)

55

IDEA #75 | PAINT A FIGURE IN MOTION

Two elements enhance the movement of this piece. One is the gesture, the figure reaching out of the painting in all directions. The other is the lively surface texture. I deliberately used quick, choppy strokes to create vitality.

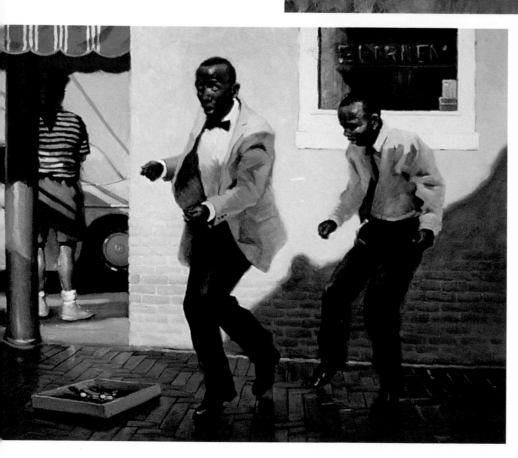

FLIGHT OF FANCY
Carole Katchen, Pastel
25" × 19"
(63.5cm × 48.3cm)

The movement here is in the placement of the dancers; they are literally up in the air, each balanced on one toe. Notice how the clothing also shows motion—the billowing sport jacket and the flopping tie.

TAP DANCERS
Xiang Zhang, Oil
24" × 30" (61.0cm × 76.2cm)

Tips on Painting People in Motion

The most challenging paintings I do are of people in motion. I want to make the viewer feel the movement. Here are some ways I have learned to make the process easier.

• Study the movement of the person. Whether your subject is a baby crawling across the floor or a ballerina leaping through the air, try to understand the physical mechanics of what's happening. Since I've studied dancing, when I want to paint a particular dance movement, I try to feel it in my own body. That helps me understand where the weight, twists and pressure are.

• Draw the movement before you paint it.

• If you are working from a photograph, know how the movement looked just before and just after the photo. Videotapes are usually better reference materials than still photos for portraying movement.

• Emphasize the gesture of the figure rather than the details. When you render every detail of anatomy, it slows down the viewer's eye and makes the figure seem stationary.

• If the figure is clothed, use the fabric to reinforce the movement. When some or all of the fabric is blurred or blended, it adds to the illusion of motion.

• Use flowing lines, angular or curving shapes, and dynamic textures to impart movement to the painting itself.

• Plan a dynamic composition. Avoid symmetry. If the figure is planted in the exact center of the format with a perfectly balanced background, it appears rooted in that position, unable to move.

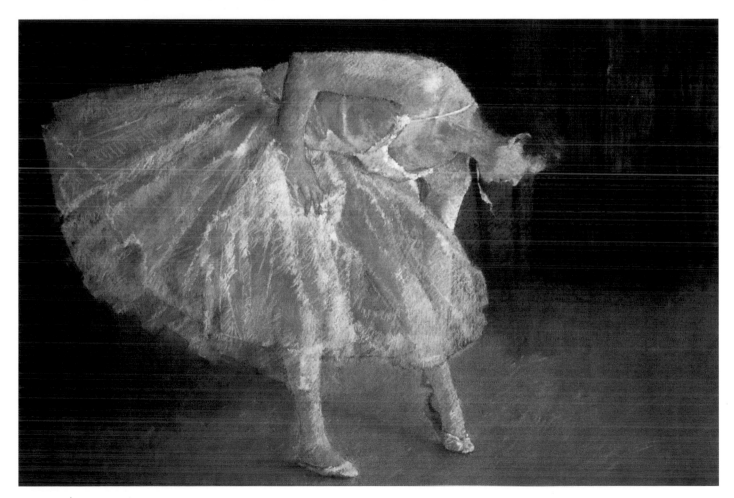

IDEA #76 | PAINT A FIGURE ABOUT TO MOVE

BALLERINA
Lilienne Emrich, Pastel
37" × 31" (94.0cm × 78.7cm)

With the figure in this awkward, unbalanced pose, we know that she must move soon or fall over. There is also tension in the composition with all the warm, bright color on the left side of the painting.

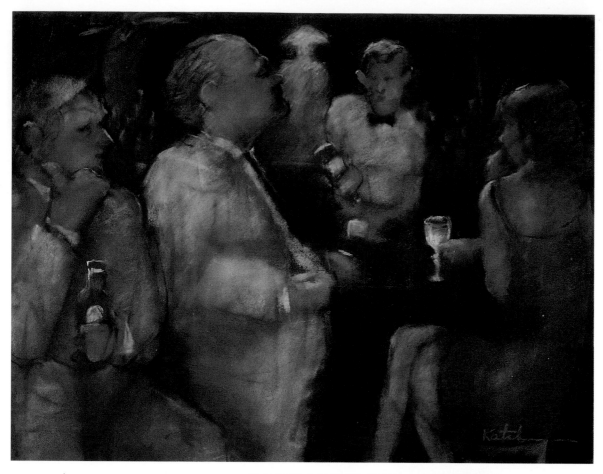

NAPOLEON
HOUSE BAR
Carole Katchen, Pastel
19" × 25"
(48.3cm × 63.5cm)

IDEA #77 | PAINT A GROUP USING DIRECTION OF THE FIGURES' ATTENTION TO MOVE THE VIEWER'S EYE AROUND THE PAINTING

Putting a group of people together is like assembling a puzzle. All the shapes of positive and negative space must fit in an interesting way. In addition, I like to use the direction of the figures' attention to move the viewer's eye around the painting. The woman is looking at the bartender. The bartender is looking at the two men. The men are looking at the woman.

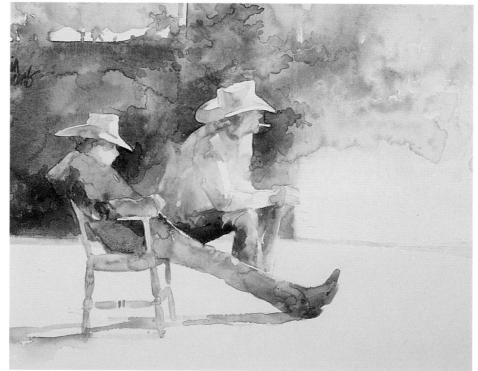

COWBOY
CONVERSATION
Robin Young
Watercolor
9" × 12"
(22.9cm × 30.5cm)

IDEA #78 | PAINT TWO FIGURES TOGETHER

These two figures merge together to form one shape in the composition. When planning a composition with more than one figure, it's vital to take into consideration the abstract shapes of the people.

More Inspiring Ideas

IDEA #79 | PAINT A FIGURE BY CANDLELIGHT

Painting a figure in dim light, especially with a single light source, creates an intense mood. It can be romantic, melancholy, even ominous. Few of the features are defined in soft light, so the mood is developed with color, value and pose.

IDEA #80 | PAINT A SOLITARY FIGURE AS A SMALLER PART OF A TOTAL COMPOSITION

Notice how much personality McCaw conveys with little detail and no facial features. The figure seems shy because of the tilted head, modest costume and turned-in feet.

MEMORIES
Dan McCaw, Oil
20″ × 20″ (50.8cm × 50.8cm)

IDEA #81 | PAINT A CROWD

When you put a large number of figures together, they cease to be individuals, but become a large mass of smaller elements. In this piece the mass takes on a texture that contrasts with the patterns of the triangles and stripes.

AT THE JAZZ FESTIVAL
Carole Katchen, Pastel
9″ × 12″ (22.9cm × 30.5cm)

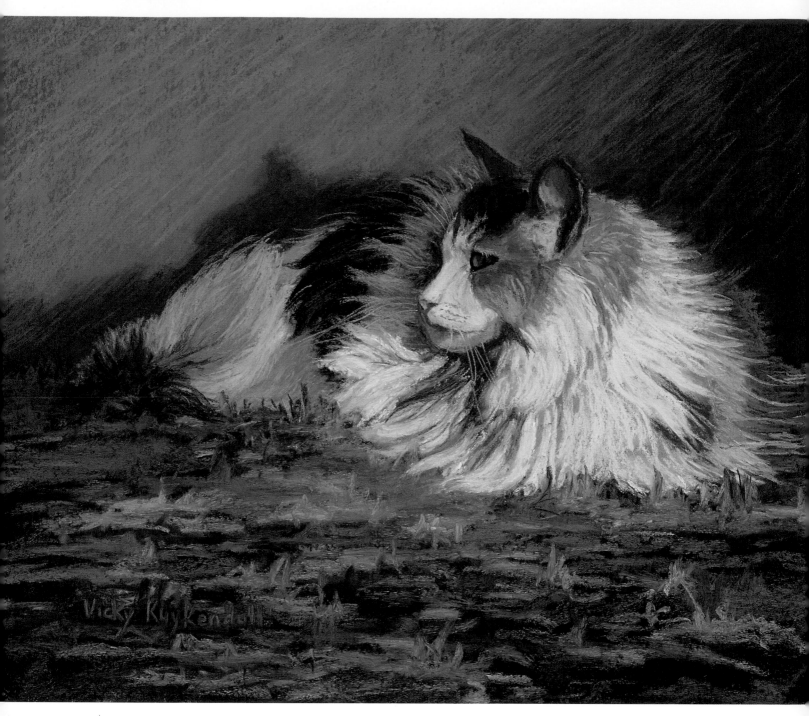

IDEA #82 | PAINT A PORTRAIT OF YOUR PET

WILLIE THE RANCH CAT
Vicky Kuykendall, Pastel
10" × 12" (25.4cm × 30.5cm)

This is a wonderful, unsentimental portrait of a pet. In this simple composition the artist focuses on form and color. The combined use of blended and unblended pastel strokes conveys the lushness of the cat's fur.

Use Your Animal Instincts

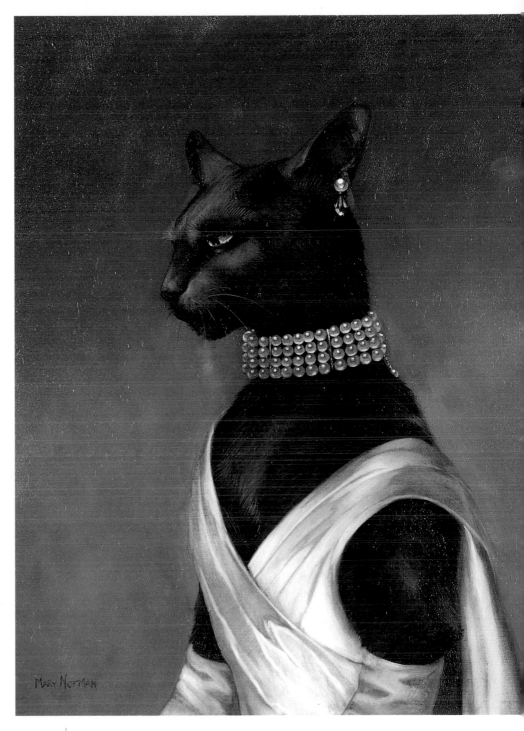

Animals are among the most difficult subjects, because your first challenge is learning how to paint a particular animal's anatomy. It's hard to take a painting seriously when the horse in it is shaped like a dog. Among wildlife artists and their supporters, anatomical accuracy is a must.

How you show an animal's size in a painting is important. An elk is large. A squirrel is small. How do you show that?

Each type of animal has its own character; as any pet owner will tell you, every individual animal has its own personality. Many of these qualities can be conveyed by composition and painting technique. Your colors, shapes, values and strokes should all be consistent with the nature of the animal you portray.

IDEA #83 | AS A VISUAL JOKE, PAINT AN ANIMAL IN A HUMAN COSTUME

LADY X
Mary Norman, Oil
12" × 9"
(30.5cm × 22.9cm)

Like all jokes, the success of this idea depends on how well the joke is told. Mary Norman achieves a witty statement by executing this painting with brilliant craftsmanship, paying careful attention to detail, skillfully modeling forms and never forgetting the feline dignity of her subject.

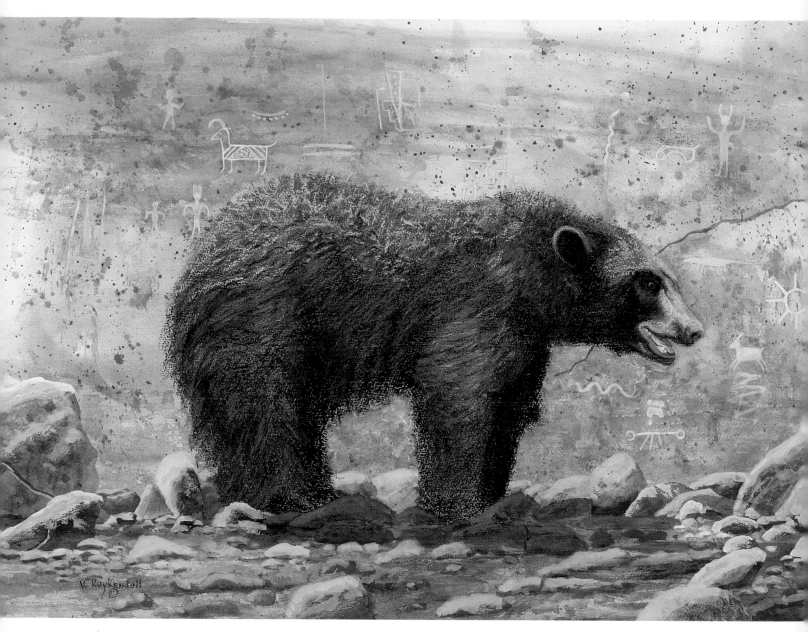

IDEA #84 | PAINT A WILD ANIMAL

OUT OF BOUNDS—BLACK BEAR
Vicky Kuykendall, Mixed Media
28" × 36" (71.1cm × 91.4cm)

The large, dark form of this animal convinces the viewer of its imposing size and strength. Kuykendall has carefully rendered its contours without enclosing its form in an outline, which would flatten out the shape; instead she leaves a loose, textured edge to imply fur.

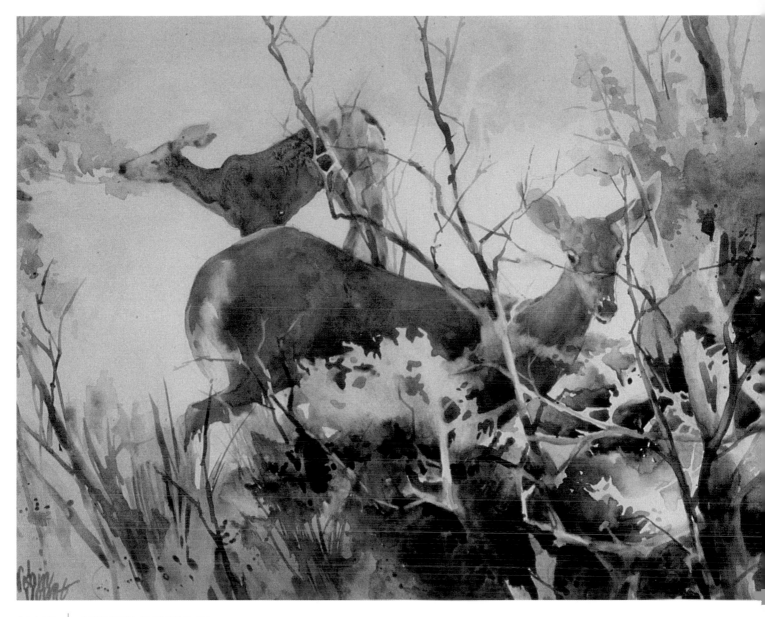

IDEA #85 | CAPTURE ANIMALS IN THEIR NATURAL HABITAT

Not all successful animal paintings are classical renderings. These stylized deer are part of a more abstract painting. It's important that the lyrical treatment of the animals is consistent with the foliage around them.

MONHEGAN DEER PEOPLE
Robin Young, Watercolor
14" × 20" (35.6cm × 50.8cm)

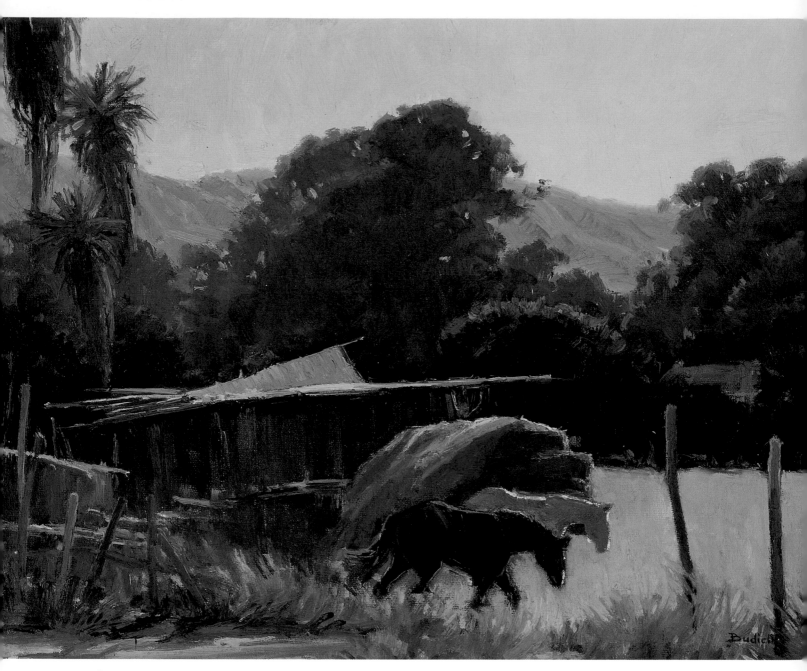

IDEA #86 | PAINT FARM ANIMALS AS SMALLER ELEMENTS IN A LARGER SCENE

Horses are one of many elements in this pastoral scene. Anatomy and gesture should still be accurate even when you're including animals as a minor part of a painting. Otherwise, the animals could strike a jarring note that distracts from the larger image.

CALIFORNIA PASTURE
John Budicin, Oil
14" × 18" (35.6cm × 45.7cm)

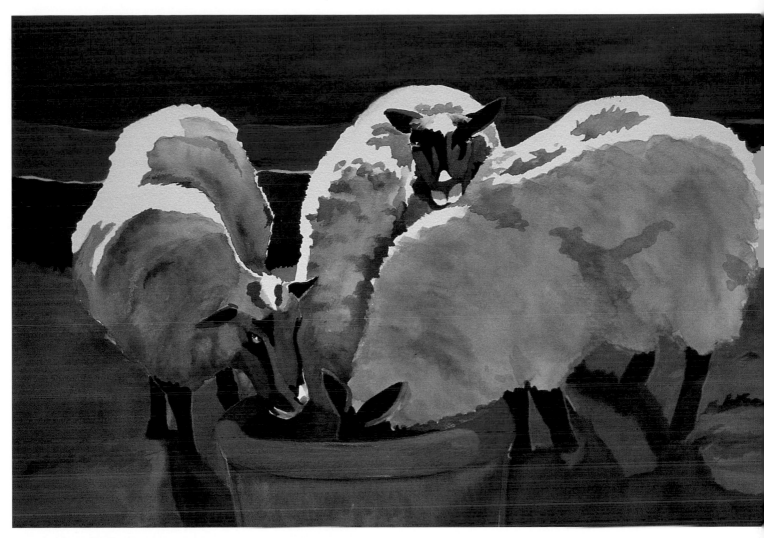

IDEA #87 | PAINT ANIMALS FROM A PHOTO BY REARRANGING ELEMENTS

Stevens moved this cluster of sheep up for a stronger composition. She punched up the colors, continuing the vibrant green and red into the sheep's bodies. She defined their faces and added a focal point by turning one sheep head so the animal is staring straight at us.

SHEEP FEAST III
Colleen Newport Stevens, Watercolor
22" × 30" (55.9cm × 76.2cm)

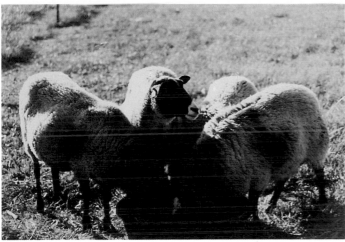

Photo reference

IDEA #88 | PAINT A SEASON OF THE YEAR

The warm yellow, orange and red foliage here is the most obvious clue that this painting is an autumn scene. Other seasonal clues can be bare branches for winter, budding branches for spring, lush gardens for summer and harvested crops for fall.

VERMONT AUTUMN
John Pototschnik, Oil
30" × 12" (76.2cm × 30.5cm)

Enjoy the Scenery

Out of so many possible landscapes, what makes one particular scene a good subject for a painting? There's something about the view that either catches your eye or involves your emotions.

More than any other subject matter, the technical components of a landscape are what make it work. The design of shapes, colors, values and textures is crucial. So a landscape artist must learn to see a scene in terms of its abstract components. Forget that this is a tree, that's a mountain, there's a barn, here's a river. All these elements are shapes of color, value and texture. As exciting as they are in their abstract relationships, that's how exciting the painting will be.

Involving the emotions is a bit more complicated. You might be drawn to a landscape painting just because it reminds you of a place you've enjoyed. However, the painter has no way of knowing where the viewer's been. The artist might stick with familiar scenes, but repeating an often-painted view can become a cliché.

How else to evoke an emotional response? Go back to the technical components. Most good landscapes establish a mood, such as peace, warmth, dignity or intimacy. These moods are the result of color, value and division of space. For example, a painting with mostly warm colors feels happier than a painting done in cool colors. A composition where values are close together and edges are soft is more peaceful than a painting where sharp darks and lights are juxtaposed.

Take the time to study the abstract components of outdoor scenes. Sit on a rock in the sunshine somewhere, taking the time to just look at all the dark and light shapes around you. Go out in the morning and study color as it changes through the early hours of the day. There's no substitute for observation. No matter how good a photograph is, it still misses many color and value nuances. Even if you shoot a whole roll of film in one location, you'll still be better able to paint a compelling landscape if you take the time to observe, sketch contours and values, make color notes.

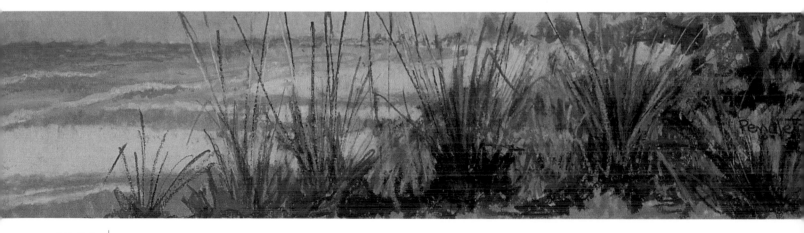

IDEA #89 | TRY A WIDE-ANGLE VIEW

A new format can give your painting a totally fresh approach; changing the shape of your paper or canvas forces you to use a different configuration of shapes within the painting. This challenge makes you search your subject for elements you may have otherwise overlooked.

SHADOWS
Pat Pendleton, Oil Pastel
15" × 27" (38.1cm × 68.6cm)

DEMONSTRATION
Paint the Sky

IDEA #90 | STUDY THE LIMITLESS SHAPES, VALUES AND PATTERNS OF THE SKY

Steven Gordon spends hours studying the sky above his Napa Valley home. This piece includes just enough earth to anchor the painting, while the rest of the composition is devoted to subtle sky and cloud variations.

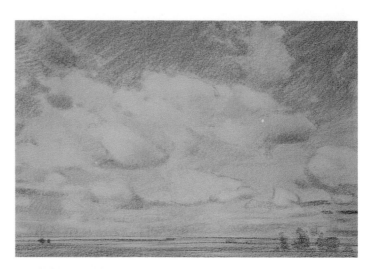

STEP ONE
Lightly Sketch Shapes and Colors
Gordon loosely sketches in the main shapes and lightly indicates color placement.

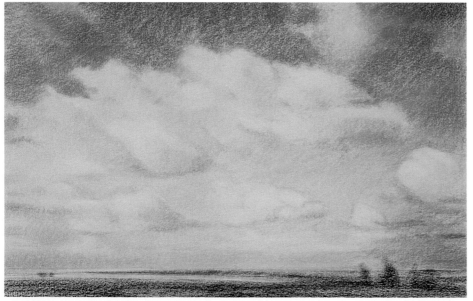

STEP TWO
Begin Developing Values
Gordon establishes the sky areas and ground that will have the darkest values. This creates a frame for the clouds, which are his primary interest. He begins to develop shapes within the clouds.

STEP THREE
Intensify Sky and Ground Colors
Gordon intensifies sky and ground colors. The sky, which always gets darker as it ascends from the horizon, goes from light turquoise near the clouds to dark blue at the top.

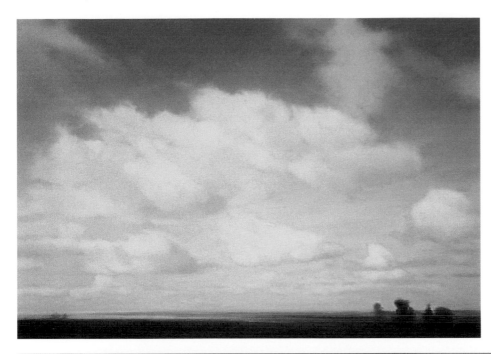

STEP FOUR
Refine Cloud Forms
Gordon refines the cloud contours and continues to develop their three-dimensional shapes. Don't forget clouds have volume and need to be modeled like other solid forms.

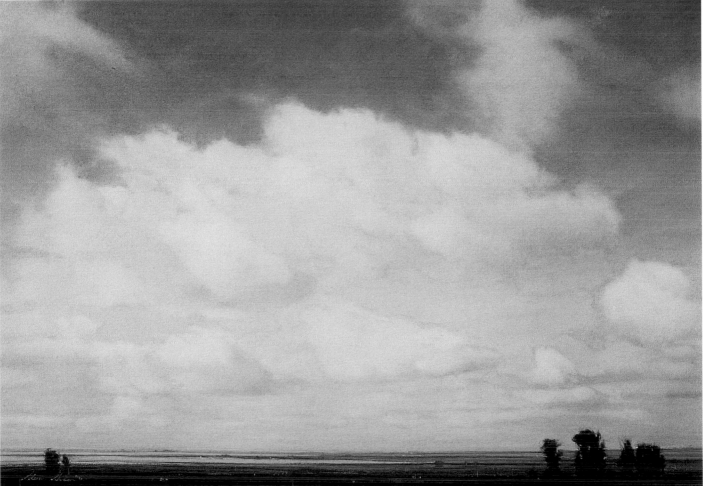

STEP FIVE
Finish Defining Ground
Gordon finishes by defining the ground area. Water is indicated as a flat sheet going off into the distance. Light falls on the meadow; the trees have specific contours, with light areas of negative space. The clouds rise up in a shining mass from this solid base.

MOUNT TAMALPAIS
Steven Gordon, Pastel
28" × 40" (71.1cm × 101.6cm)

69

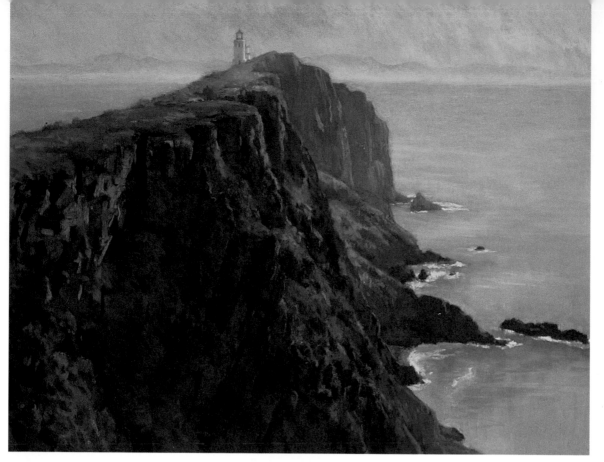

IDEA #91 | GIVE YOUR SCENE GREATER IMPACT BY CHOOSING A DRAMATIC VIEW FROM ABOVE

By painting from the top of the cliff looking down at the water, Hartmann gives this subject greater dramatic impact. Getting up above a scene changes all the shapes and relationships, making a fresh subject from what might have been an overly familiar view.

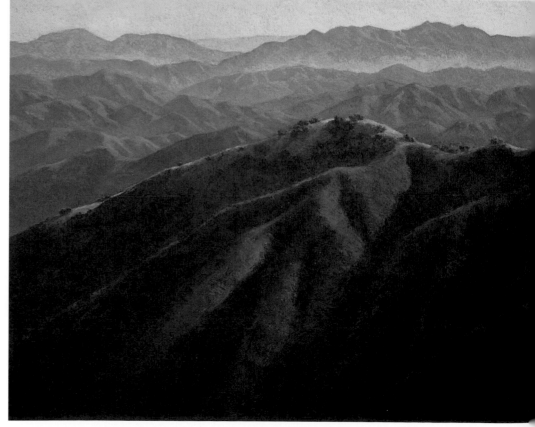

IDEA #92 | PAINT A DISTANT SCENE

A large subject such as this mountain range alters the scale of things; a tree that would be prominent in another composition is now reduced to a small dot. Light and shadow become vital for defining hill and valley masses.

BACKCOUNTRY SUNRISE
Glenna Hartmann, Pastel
24" × 29¼" (61.0cm × 74.3cm)

IDEA #93 | PAINT A VIEW WITH NO SPECIFIC DETAILS

In this very abstract landscape treatment, Justus focuses on the contours of the land and the light falling on it; a few simple strokes suggest distant trees. In an abstract piece like this, the character of the paint strokes following the contours of the earth becomes more important than in another type of treatment.

THE RIDGE
Dolores Justus, Oil
20" × 16" (50.8cm × 40.6cm)

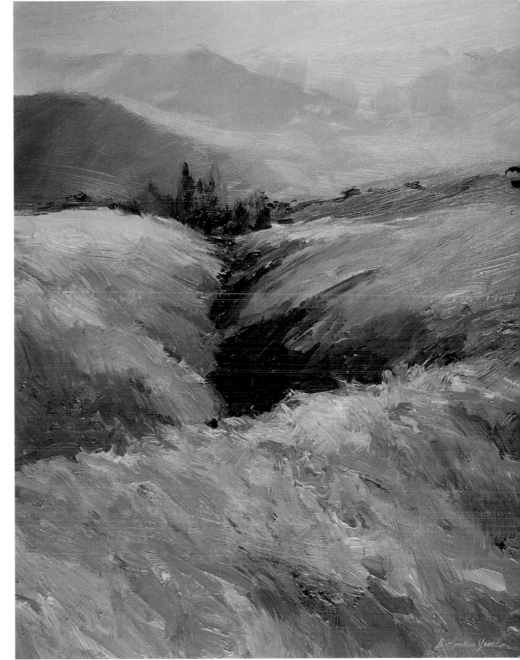

IDEA #94 | FOCUS ON ONE LANDSCAPE DETAIL

Palmer limited this painting to the pattern of branches in one section of a tree. With no background or other objects to distract her, she's free to develop the form and rhythm of sharply curving twigs and branches. In a painting like this, negative spaces are as important as the tree itself.

TREE OF HEARTS
Linda Palmer, Prismacolor
41" × 54" (104.1cm × 137.2cm)

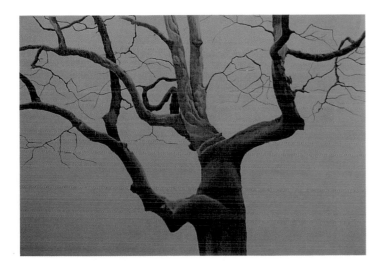

71

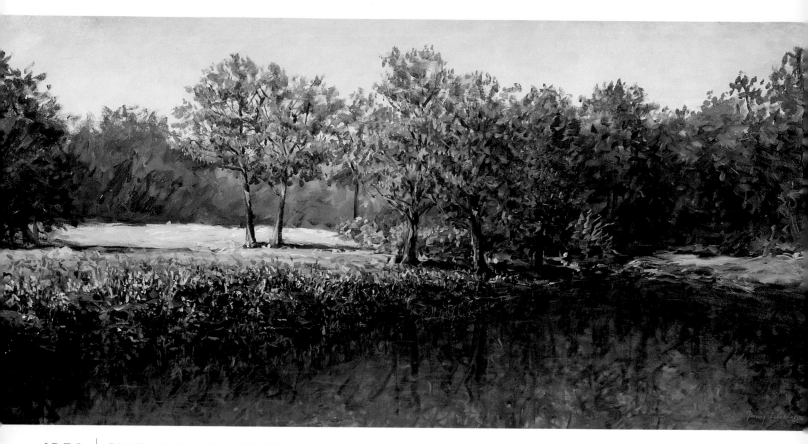

IDEA #95 | PAINT A SUNNY DAY WITH STRONG CONTRASTS BETWEEN AREAS OF LIGHT AND SHADOW

In this painting, Leach has also painted bright accents on tree trunks, leaves and grasses.

LAKE'S EDGE
Jimmy Leach, Acrylic
24"×48" (61.0cm×121.9cm)

Tips on Painting the Effects of Weather

• Bright, direct sunshine will often wash out colors, yet in shadows cast by strong sun, the colors are more intense; you might see strong blues, purples, greens and reds, even in shadows on skin. Cast shadows are strongest when the sun is shining brightly; their direction and length changes as the sun moves across the sky.

• On a cloudy day, light is muted and cast shadows are undefined.

• On a foggy or rainy day, values remain in the middle range and colors tend to be grayed. Moisture in the air softens edges.

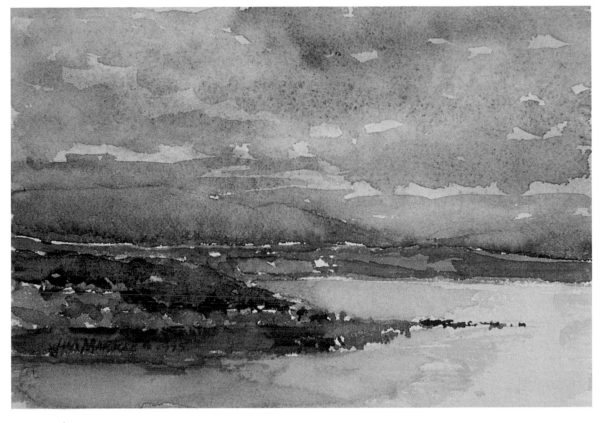

ACHILL SOUND
Jim Markle, Watercolor
3¹/₄" × 5¹/₄"
(8.3cm × 13.3cm)

IDEA #96 | PAINT A RAINY SKY BY USING BLURRED WATERCOLOR EDGES AND SOMBER COLORS

Markle uses several techniques to create the impression of wet weather. Working in very wet watercolor, the resulting blurred edges help create the feeling of rain. He also uses dull colors—somber browns and purples— for the cloud-filled sky.

IDEA #97 | PAINT AN EARLY-MORNING FOG

BELOW OAKVILLE GRADE
Steven Gordon, Pastel
9" × 24" *(22.9cm × 61.0cm)*

This painting looks like early morning when the sun is low, the light is warm and the sky is filled with mist. Moisture in the air causes edges to soften and details to disappear. To make the painting look more like a cold winter fog, colors would have to be grayer and cooler.

73

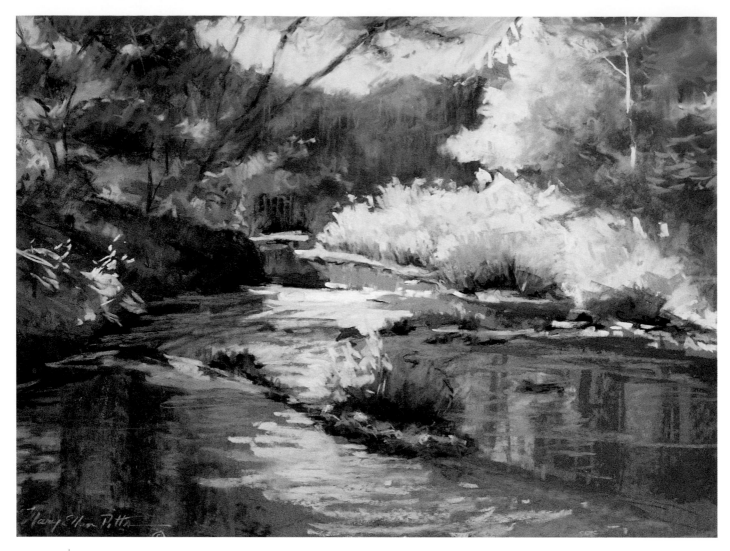

IDEA #98 | CREATE INTERESTING SHAPES BY PAINTING A WINDING RIVER

Water in a rushing river like this one reflects all the colors surrounding it, with white or very light colors showing turbulent foam where water strikes the river rocks. Pitts uses the river winding back and forth across her composition to divide it into interesting shapes.

GLORY
Mary Ellen Pitts, Pastel
12" × 16" (30.5cm × 40.6cm)

IDEA #99 | PAINT THE CHOPPY SURFACE OF WAVES WHERE THE OCEAN MEETS THE SHORE

Water in an ocean moves with the tide, so the surface is choppier with white foam on the waves where it comes close to the shore. Rough water near the shore stirs up sand and dirt on the bottom, so the color there appears more brown.

HIGH TIDE—CAMBRIA
Urania Christy Tarbet, Oil
8" × 10" (20.3cm × 25.4cm)

74

Tips on Painting Water

- Water takes much of its color from what it reflects; it looks bluer when it's reflecting a blue sky, grayer with a gray sky.
- Still water reflections are less broken up than in moving water. The pattern depends on the source of movement—a pebble tossed into a lake creates circles; the wake of a boat shows up as diagonal lines.
- Foam or spray increases with water movement.

IDEA #100 | PAINT THE SUBTLE SHADES OF THE DESERT

Lack of water makes desert colors muted. Martin delineated a few sage plants in the foreground to provide a center of interest, then let the rest blend together and fade into the distance. Color contrast adds excitement—cool blue-green plants against warm pink earth.

VERMEJO
Dale Martin, Pastel
11" × 14" (27.9cm × 35.6cm)

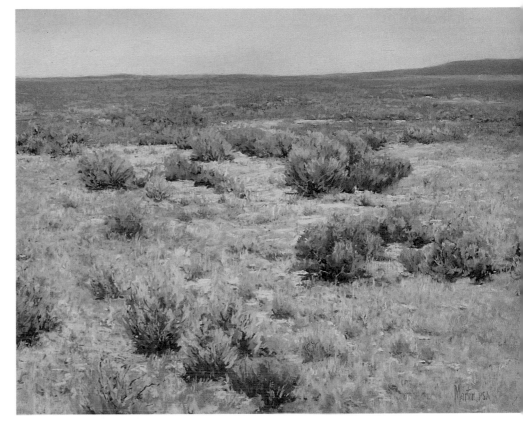

IDEA #101 | ADD A STILL LAKE TO YOUR LANDSCAPE

The character of a body of water varies according to size, shape and water movement. Because water in a lake is stationary, the surface stays relatively still. That causes smooth reflections like the ones in this painting. Water is blue where it reflects sky. Bits of orange underpainting show through the complementary blue to make the color vibrate.

SEA PINES
Marian Hirsch, Pastel
14" × 18" (35.6cm × 45.7cm)

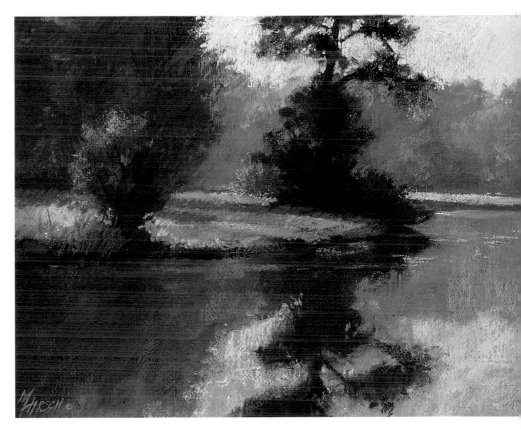

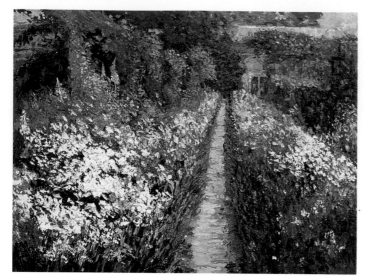

Create the illusion of spatial depth, then use a device to lead viewers into that space. Diminishing size is a primary technique to create spatial depth; the flower shapes in this painting get gradually smaller as they recede in space.

MONET'S PATH
Urania Christy Tarbet, Oil
24" × 30" (61.0cm × 76.2cm)

Tips on Composing Landscapes

• Give structure to your design by dividing the scene into a few large shapes. Make those shapes uneven in size and form to give the composition vitality. As you develop your painting, divide each large shape into smaller shapes, still being aware of the original division of space.

• To create spatial depth, separate the image into foreground, middle ground and background. Color, value contrast and details should be strongest in the foreground; the scale of objects should be largest there. These characteristics decrease as you recede into space.

• Choose a main focal point: an object such as a house or tree, an area of bright color, or an area of intense value contrast. Additional, secondary focal points keep the viewer's eye moving around the painting.

• Use surface texture to define shapes—for example, short, choppy strokes in a grassy area next to smoother, longer strokes for the sky.

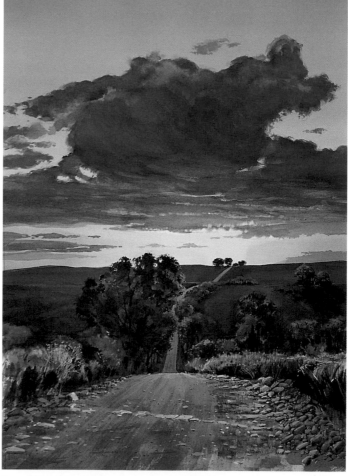

FLINT HILLS SUNSET
Wilbur Elsea
Watercolor
22" × 16"
(55.9cm × 40.6cm)

By taking this road up and down over the contours of the hills, Elsea creates the impression that it continues for a very long way.

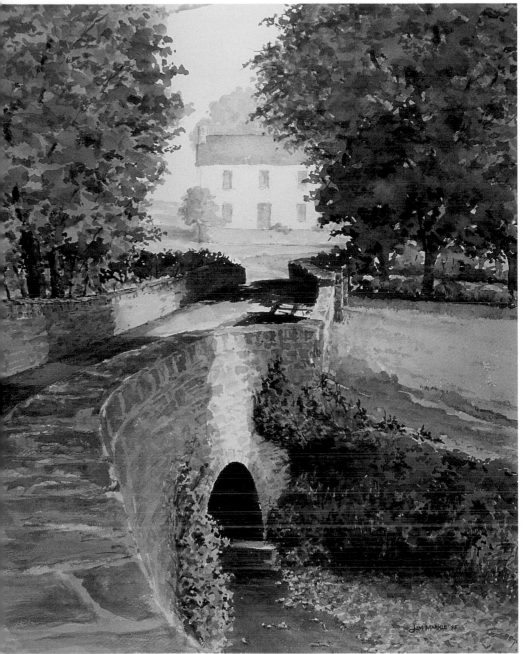

This bridge not only leads into the painting, but also provides an opportunity for some wonderful textural variations. The pattern of the stones contrasts with the textures of foliage and pebbles.

BRENDON BRIDGE
Jim Markle, Watercolor
18" × 13½" (45.7cm × 34.3cm)

ARROYO HONDO
Ed Pointer, Oil
12" × 16"
(30.5cm × 40.6cm)

Pointer intensifies this perspective view of the river by repeating the blue in the distant mountains. Viewers' eyes begin with the blue river and are then pulled into the distance to connect the two blue forms.

IDEA #103 | PAINT A COMPOSITION USING A VARIETY OF DIAGONALS

Diagonal lines and shapes automatically add more movement to a composition than vertical or horizontal lines. In this composition the foreground covers the lower left half of the paper, cutting diagonally from upper left to lower right. Background mountains are also diagonal, but with a gentler slope.

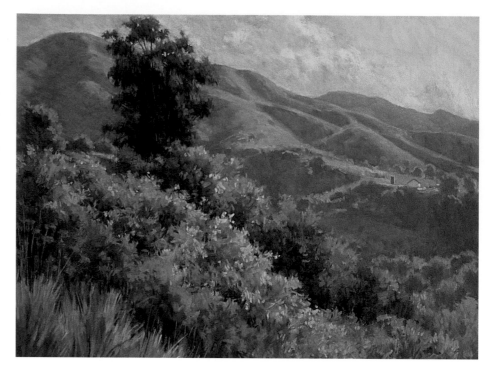

SPRING FOOTHILLS
Glenna Hartmann, Pastel
17¼" × 23" (43.8cm × 58.4cm)

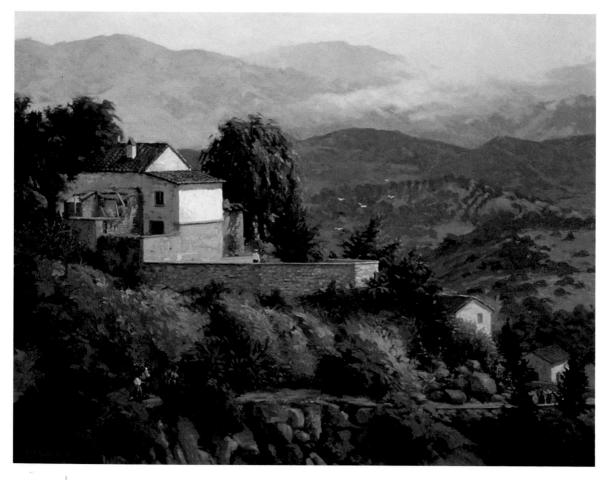

MORNING IN RHONDA
John Pototschnik, Oil
24" × 30"
(61.0cm × 76.2cm)

IDEA #104 | ENHANCE YOUR LANDSCAPE WITH HUMAN FIGURES

Besides adding another visual element, people add a narrative effect. Viewers become more involved in the painting by wanting to know who these people are and why they are there.

IDEA #105 | ADD A CLUSTER OF ANIMALS TO YOUR LANDSCAPE

The cattle at center foreground add an interesting textural element. The color in this painting is wonderful, especially the repetition of pink and purple from the sky in accents on the water, and even on the animals.

EVENING RADIANCE
John Budicin, Oil
18" × 24" (45.7cm × 61.0cm)

IDEA #106 | PUT THE GEOMETRIC DESIGN ELEMENTS OF BUILDINGS INTO YOUR LANDSCAPE

The sharp, straight lines of this barn provide a counterpoint to the more organic shapes and edges of natural forms.

COE RANCH
Gary Myers, Watercolor
15" × 22" (38.1cm × 55.9cm)

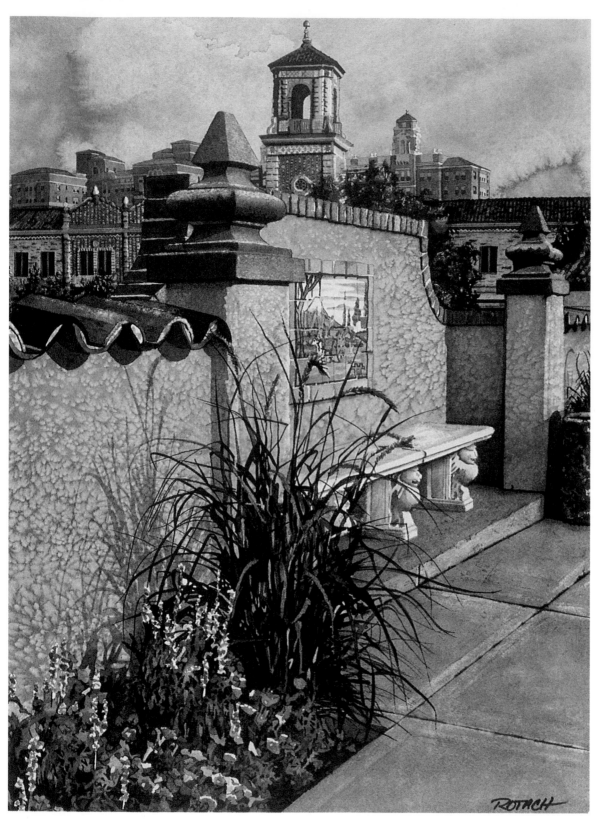

PLAZA EVENING
Marlin Rotach
Watercolor
18½" × 13"
(47.0cm × 33.0cm)

**IDEA
#107** | PAINT THE INTERESTING PATTERN OF A
CITY SKYLINE OR SERIES OF ROOFTOPS

Rotach used a skyline to enrich the background of this piece, and filled the
foreground with details from Kansas City's Plaza.

Get a New Perspective on Buildings

Some buildings are intriguing because of the arrangement of shapes, lines and angles they present; others because of a mood or memory inspired by their architectural style. The function of a building affects our perception, as does its age and condition.

Because buildings are generally large and solid-looking, they represent permanence and security. Those feelings change to irony and poignancy when that building is in bad repair, abandoned or falling down.

Well-designed buildings can look graceful or elegant. The contradiction of earthbound materials like brick and steel creating a form that is charming can be an interesting subject for an artist.

Look first at the form, colors, shapes and textures of a building, then think about the feelings the building evokes. The strongest paintings combine a strong design with some underlying emotional expression.

IDEA #108 | PAINT THE INTERESTING DETAILS OF A HISTORIC BUILDING

VICTORIAN
Stanley Rames, Watercolor
22" × 30" (55.9cm × 76.2cm)

Fashion and economic considerations have dictated the streamlining of modern architecture, so old buildings often have more interesting detail than newer ones. In addition, a charming old structure like this evokes scenes from a more graceful era.

IDEA #109 | PAINT THE BASIC SHAPES OF A BUILDING FROM A DISTANCE, WITH ONLY A FEW DETAILS

ON THE ISLE
Jim Markle, Watercolor
9½" × 14" (24.1cm × 35.6cm)

Standing away from your subject allows you to see the entire form. In addition, it allows you to put the building into its environmental space.

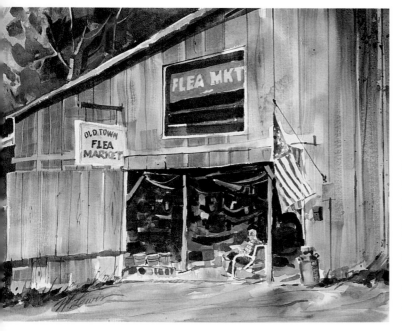

IDEA #110 | FOCUS ON PART OF A BUILDING UP CLOSE, EMPHASIZING GEOMETRIC COMPONENTS

Look at the relationship here between the rectangles of door, doorway, window and the slanting lines of the roof. The pattern of the wooden siding also becomes an element of design.

FLEA MARKET
Bill Lewis, Watercolor
14" × 18" (35.6cm × 45.7cm)

Tips on Painting Structures

• Even when you only see one wall of a building, remember the building is three-dimensional. Most buildings are a cube or a group of cubes, which will help you define the perspective.

• Before you begin painting, take time to figure out how the building is put together. Where do the walls meet? Where does the roof fit on top? You don't want to finish the painting and discover you've left a gap between the top of the wall and the roof.

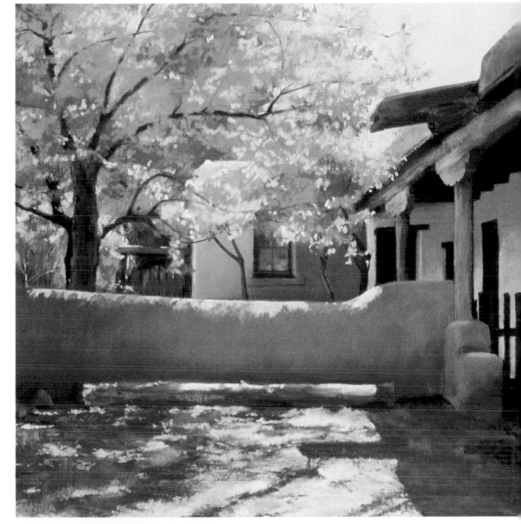

IDEA #111 | PAINT ROMANTIC ARCHITECTURE

Besides the mood this scene evokes, the adobe provides the challenge of painting walls that are never quite straight.

ACEQUIA MADRE COURTYARD
Elizabeth Sandia, Pastel
10½" × 10½" (26.7cm × 26.7cm)

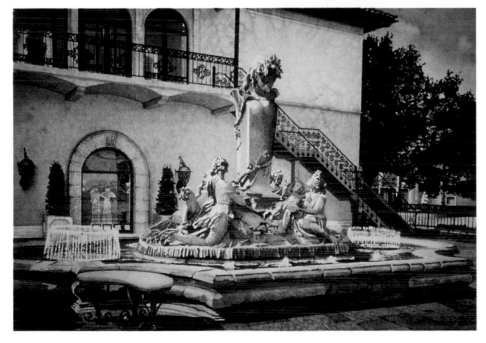

IDEA #112 | PAINT AN ARCHITECTURAL DETAIL

Rotach loves to use architectural detail as the inspiration for his precise water-colors. Here he combines the classical carved forms of the fountain, the shaped stonework and the filigreed iron railings to convey the romance of this setting.

FOUNTAIN OF BACCHUS
Marlin Rotach, Watercolor/Ink
13" × 18½" (33.0cm × 47.0cm)

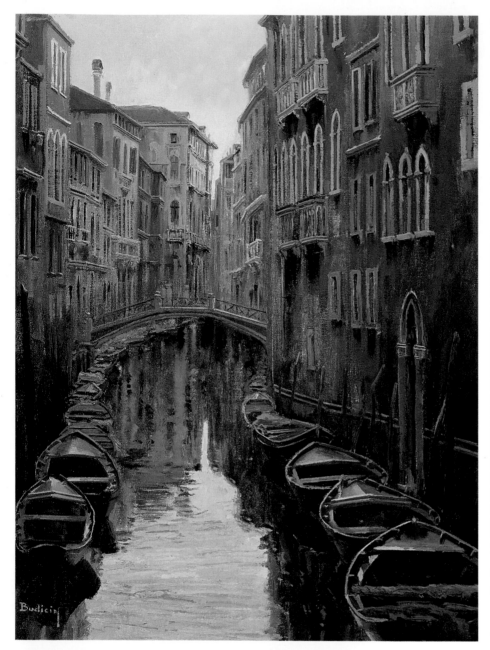

Budicin

IDEA #113 | PAINT FOREIGN ARCHITECTURE

The architecture in this painting evokes a pleasant mood. Seeing this Venetian scene, with its palatial facades and quaint boats, takes the viewer into a more charming world than many of us inhabit.

DAY BREAK
John Budicin, Oil
18" × 14" (45.7cm × 35.6cm)

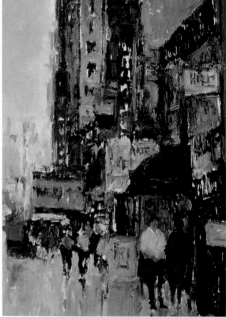

IDEA #114 | PAINT A SIDEWALK SCENE WITH LOOSE STROKES TO CREATE MOVEMENT

McCaw uses windows, signs, marquees and awnings to convey the vitality of a metropolis.

CITYSCAPE
Dan McCaw, Oil
24" × 16" (61.0cm × 40.6cm)

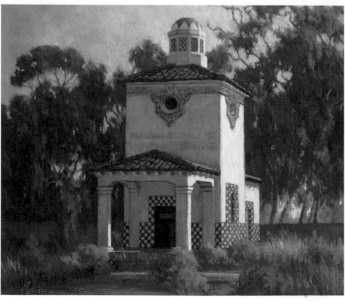

IDEA #115 | PAINT AN INTERESTING ABANDONED BUILDING

This building is much more charming than most abandoned structures. We see it is unused by the overgrown brush around it, and become engaged in wondering what its purpose was before.

BARNSDALL RIO GRANDE GAS STATION
Glenna Hartmann, Pastel
15¾" × 17½" (40.0cm × 44.5cm)

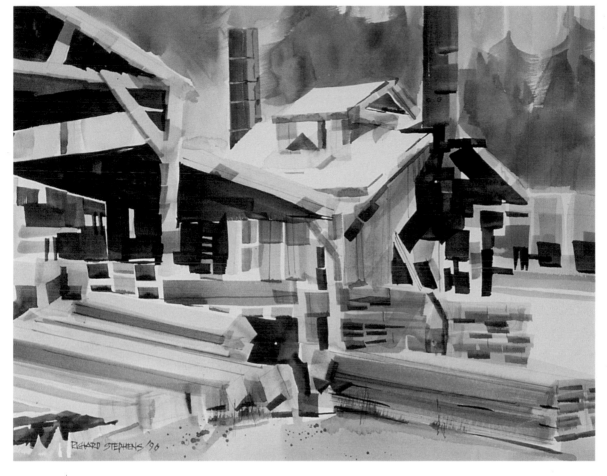

HARDWOOD
MILL
Richard Stephens
Watercolor
18" × 22"
(45.7cm × 55.9cm)

IDEA | PAINT THE NO-FRILLS GEOMETRIC
#116 | DESIGN OF AN INDUSTRIAL BUILDING

What makes this piece exciting is the rhythm of geometric patterns.

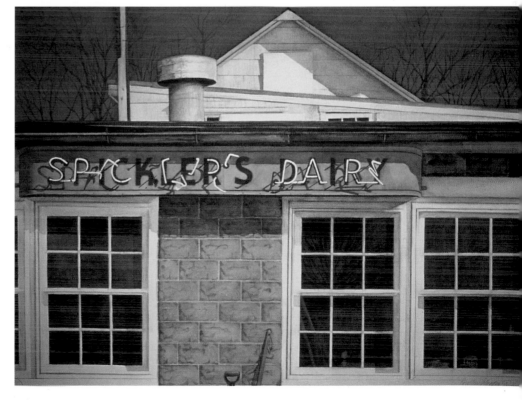

IDEA | PAINT A SIGN
#117 | ON A BUILDING

Whenever writing appears in a painting, viewers want to know what it says and what it means. It's as if they've happened upon part of a story. The lettering here identifies the building, and the decrepit condition of the sign makes the viewer wonder what has happened to it.

SPICKLER'S DAIRY
Carol Ann Schrader, Watercolor
22" × 29" (55.9cm × 73.7cm)

Paint a Street Corner

IDEA #118 | PAINT A STREET CORNER

Marlin Rotach begins his watercolors with a very precise, detailed drawing of the subject. Then he fills the colors in like a puzzle, one piece at a time. Control of the watercolor is vital in a painting of this kind. Each color is applied precisely and allowed to dry before the next is added. Most important is defining the white shapes at the beginning and keeping those free of pigment as the painting is developed.

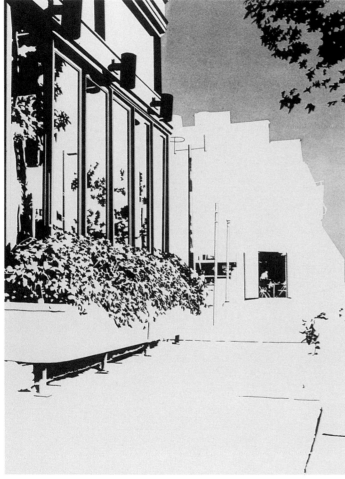

Step One

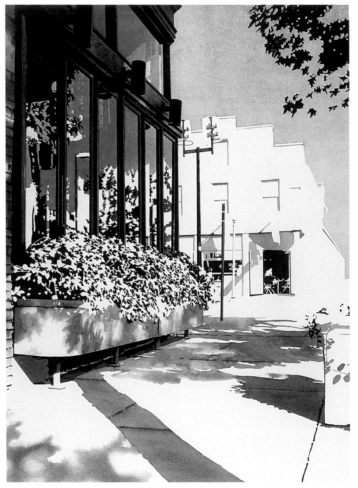

Step Two

Step Three

Step Four

Step Five

Glass is a significant element in many architectural paintings, and this artist shows how to handle it well. He uses the reflected light and images on the glass surfaces to enhance the overall composition.

WESTPORT REFLECTIONS
Marlin Rotach, Watercolor
25½" × 19" (64.8cm × 48.3cm)

Tips on Painting Interiors

• Choose a subject that shows something about the people who live there.

• Include enough architecture— walls, floor, etc.—to convince the viewer this collection of furnishings exists in three-dimensional space and is anchored by gravity.

• Be aware of your light source or sources, so you are consistent in highlights and shadows.

• Keep furnishings and figures proportional with each other.

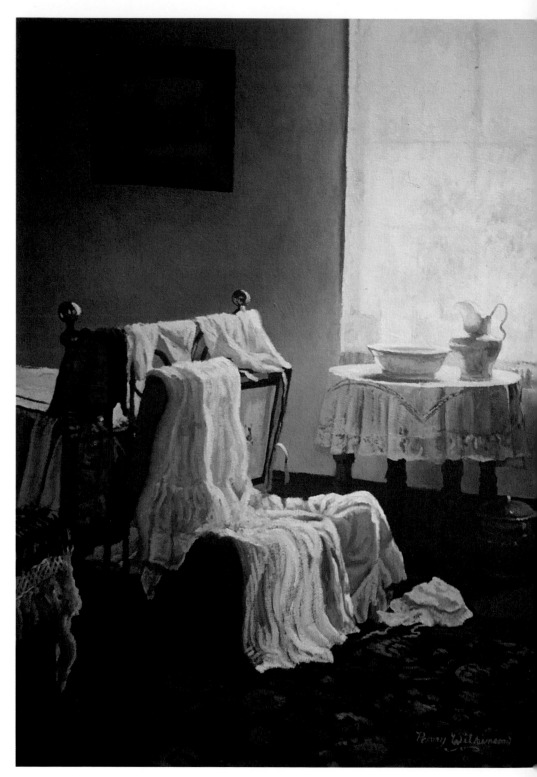

IDEA	MAKE THE VIEWER SENSE
#119	A HUMAN PRESENCE IN A
	SCENE WITHOUT A FIGURE

Wilkinson evokes a romantic mood as well. The bright sunlight and lacy fabrics create a warm, feminine feeling. Just from looking at the painting, we know this is the room of a woman.

YOUNG LIEUTENANT'S WIFE
Penny Wilkinson, Oil
24" × 18" (61.0cm × 45.7cm)

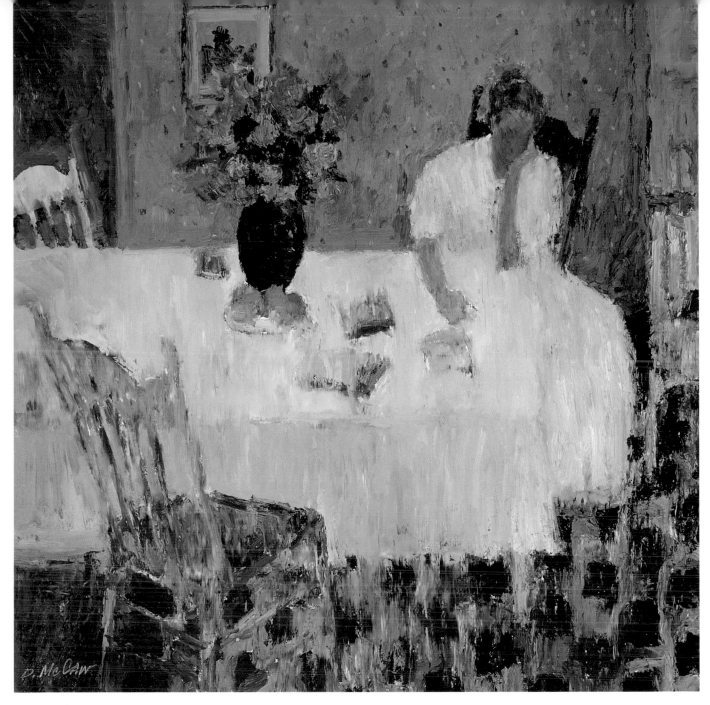

IDEA #120 | PAINT AN INTERIOR WITH A FIGURE

If the room is consistent with the figure in style and tone, the painting is harmonious and attention stays with the figure. When the setting is at odds with the figure—too big, too dark, too masculine or feminine—the contrast creates tension. We get caught up in the drama of why that figure is in that environment. Either approach can make a successful painting.

QUIET MOMENT
Dan McCaw, Oil
20″ × 20″ (50.8cm × 50.8cm)

More Intriguing Ideas

IDEA #121 | PAINT A TYPICAL NEIGHBORHOOD SCENE ON THE STREET WHERE YOU LIVE

It might be one home, a group of homes or simply a detail of a home.

IDEA #122 | PAINT THE STRONG ABSTRACT DESIGN OF A BUILDING UNDER CONSTRUCTION

The skeleton of beams and braces can be a fascinating geometric pattern. Include just enough detail to show what the subject is.

IDEA #123 | PAINT A BUILDING BEING TORN DOWN

Here you may have the crisp geometry of the building's structure along with the rough and jagged edges of the demolished portion.

OLD ENGLISH
Brooke Allison, Pastel
28" × 22"
(71.1cm × 55.9cm)

IDEA #124 | DON'T BE AFRAID TO PAINT WITH PURE, RICH COLORS

The warm red Allison features in this painting is even more powerful alongside equally powerful, cool blue tones.

Glorious Color

O f all the technical components that might inspire a painting, color is the most obvious. Sometimes a single color is enough; but it's usually the quality of the color or the relationship of colors that makes a painting come alive. Notice how the surface of your painting seems to vibrate when you place warm against cool colors, or bright against grayed colors.

Even more impressive is how color affects the subject matter or mood of a painting. Take a good subject, add vibrant color, and you now have a great subject.

IDEA #125 | BATHE YOUR PAINTING IN THE WARM COLORS OF SUNRISE OR SUNSET

SUNSET AT LEICESTER
John Pototschnik, Oil
7¾" × 12" (19.7cm × 30.5cm)

An unexceptional scene can become quite appealing when everything is toned by the warm light.

IDEA #126 | **LIMIT YOURSELF TO ONLY TWO COLORS PLUS WHITE**

KITCHEN TOWEL 1
Jo Ann Leiser, Watercolor
15″×22″ (38.1×55.9cm)

Leiser wanted to find out what was the least amount of color she could use and still paint complete paintings. The resulting simplicity of color adds a stark elegance to these compositions.

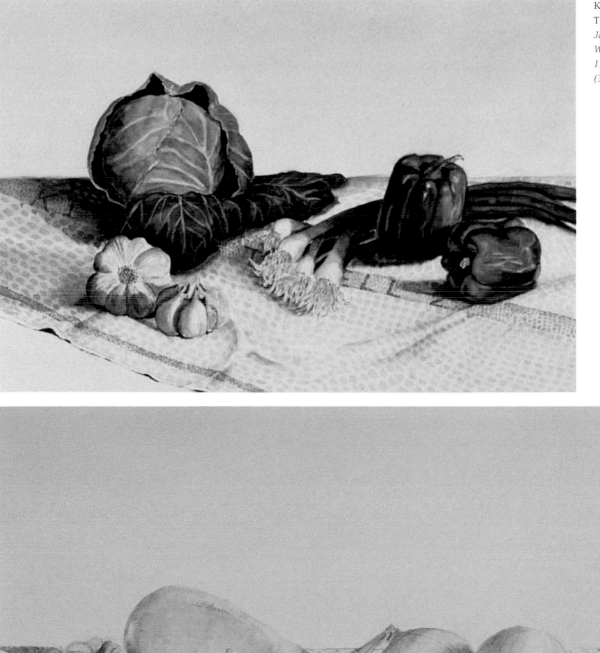

KITCHEN
TOWEL 2
Jo Ann Leiser
Watercolor
15″ × 22″
(38.1cm × 55.9cm)

KITCHEN TOWEL 4
Jo Ann Leiser, Watercolor
15″ × 22″ (38.1cm × 55.9cm)

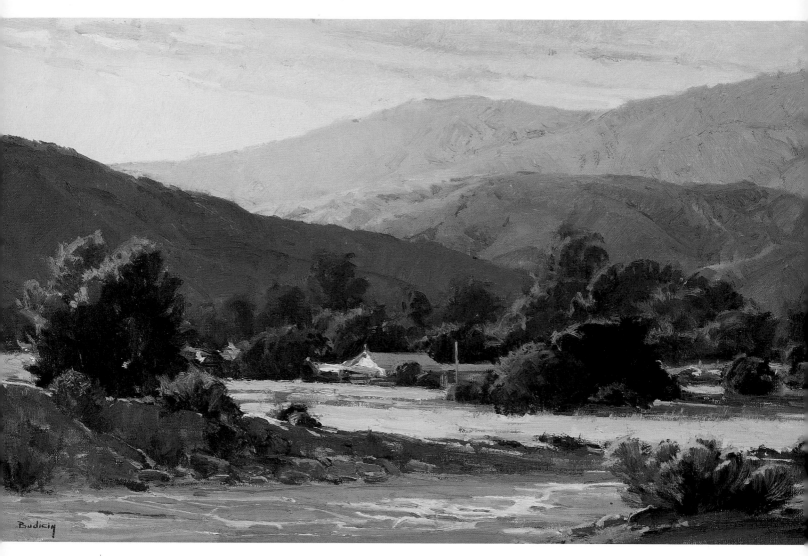

IDEA #127 | ALTERNATE COMPLEMENTARY COLORS

Except for the green foliage, this painting consists of alternating bands of complementary yellow and purple. Because it is next to purple, the yellow takes on a rich glow that conveys the character of late afternoon light.

GOLDEN GLOW
John Budicin, Oil
14" × 22" (35.6cm × 55.9cm)

Tips on Painting With Color

- An area of color appears richer if you paint it with strokes of related colors rather than just one solid color. For instance, try adding small amounts of green, purple or even pink to a section of blue sky.

- Placing strokes of warm color next to strokes of cool color gives the surface more vitality.

- Bright colors look brighter when surrounded by dull or grayed colors. They seem more electric when next to their complementary color.

- The color of the light source changes all the colors in a scene. To demonstrate this phenomenon, set a few objects on a table. Shine a red light on the tabletop. Then shine a blue light on the same objects. The objects appear to change color.

- If the light source is warm, shadows are relatively cooler, and vice versa.

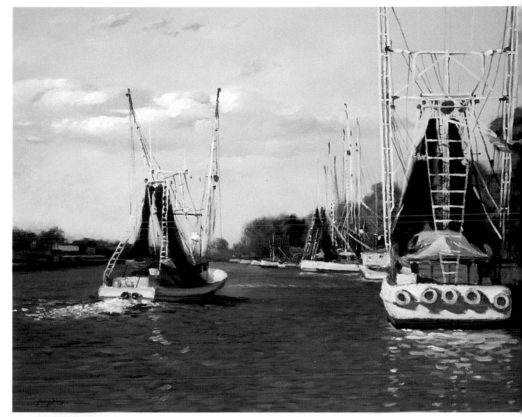

IDEA #128 LOOK FOR COLORS IN REFLECTIONS

We think of water as blue, but it actually reflects the color around it. The blue is a reflection of the sky, and the yellow in the water is the reflected boat color. By emphasizing those colors, Zhang has made the reflections a vital part of his composition.

FISHING VILLAGE
Xiang Zhang, Oil
22" × 28" (55.9cm × 71.1cm)

IDEA #129 EXPRESS A SENSE OF ENERGY WITH INTENSE COLOR

The exaggerated colors in this piece express the exuberance of a gospel choir performance.

TELL IT ON THE MOUNTAIN
Carole Katchen, Pastel
12" × 9" (30.5cm × 22.9cm)

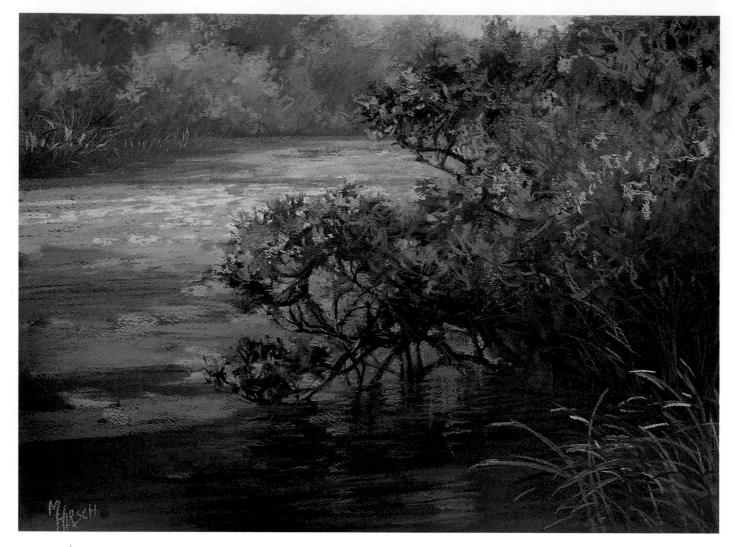

IDEA #130 | FIND THE HIDDEN COLORS IN NATURE AND PUSH THEM TO A DRAMATIC CONCLUSION

Beginning artists believe water is blue and grass is green, but the more you paint and observe, the more you realize everything in nature contains many hidden colors.

WATERWILLOWS I—WILLS POINT
Marian Hirsch, Pastel
21" × 28½" (53.3cm × 72.4cm)

IDEA #131 | INVENT OR EXAGGERATE COLORS TO CREATE A MORE EXCITING DESIGN

The photograph of these burros is virtually monochromatic. Stevens invents colors for the ground, the background, even the animals. When inventing or exaggerating color, be concerned about maintaining color harmony within the painting.

ALAMOS AFTERNOON
Colleen Newport Stevens, Watercolor
22" × 30" (55.9cm × 76.2cm)

Photo reference

Another Bright Idea

IDEA #132 | DEVELOP A PAINTING WITH COLORS YOU NEVER USE

Over the years an artist develops favorite colors—colors to turn to again and again no matter what the subject. Other colors never appeal to you, so you avoid them. The unused colors are obvious to a pastel artist; they're the ones that never leave the box. For watercolorists or oil painters who use a limited palette, it's a little harder to find them. Use the colors of your palette to mix a wide variety of colors, then pick the least appealing of those colors. The finished painting will have unexpected color combinations and relationships you might find very exciting.

Glowing Light

Master painters throughout the years have said they never paint any subject except light. No matter what objects or figures are in the composition, the function of those objects or figures is only to provide contours for the light to fall upon.

Light changes with direction, intensity, time of day, time of year, weather conditions. The light of the sun creates different effects than the light of a candle. The light of a lamp is vastly different from the light of a fire. Humidity in the air can make lights appear softer.

You can read about it and talk to scientists about it, but the only way to truly understand light is to observe it. Pick a spot outdoors. Watch your surroundings change in color and value as the sun moves across the sky. As you study light, you'll find it supplies you with innumerable ideas for paintings.

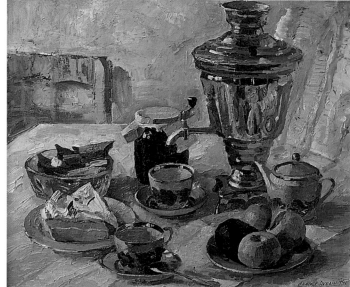

STILL LIFE WITH
RUSSIAN
SAMOVAR
Anatoly Dverin, Oil
19½" × 23"
(49.5cm × 58.4cm)

IDEA #134 | PAINT REFLECTIONS ON POLISHED METAL

Reflected images can be used to balance the composition. In some paintings they are used to convey imagery outside the picture plane.

IDEA #133 | DRAMATICALLY LIGHT A FIGURE FROM BELOW

Creating highlights in places where shadows normally fall gives a unique effect.

MODEL WITH A SLIDE
Jerald Silva, Watercolor
48" × 36" (121.9cm × 91.4cm)

IDEA #135 | PAINT REFLECTIONS ON THE SURFACE OF GLASS

Where light hits glass directly, it loses all of its color. In this painting, George stylized the light, painting pure black next to pure white to maximize the contrast.

EMPTY CRYSTAL IV
Karen George, Watercolor
26" × 40" (66.0cm × 101.6cm)

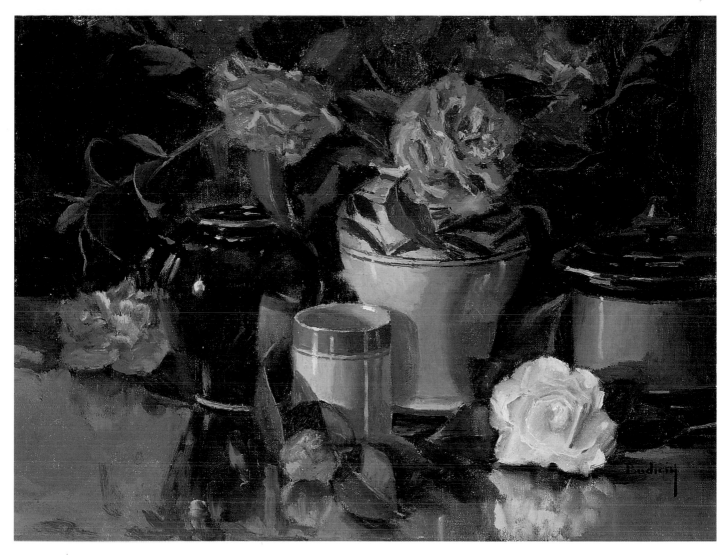

IDEA #136 | PAINT REFLECTIONS ON GLAZED CERAMIC

Glazed ceramic picks up reflections of surrounding color as well as light. Notice how this entire painting seems to have a pink glow from the reflected color on the pots and tabletop.

THE WHITE CAMELIA
John Budicin, Oil
12" × 16" (30.5cm × 40.6cm)

IDEA #137 | PAINT THE SHAPES AND VALUES OF REFLECTIONS ON STILL WATER

Although water is sometimes described as mirrorlike, it rarely reflects fine details or specific contours. In this painting there is a mirror effect with the shape and value of the trees, providing an interesting compositional element.

REFLECTING
Steven Gordon, Pastel
14" × 28" (35.6cm × 71.1cm)

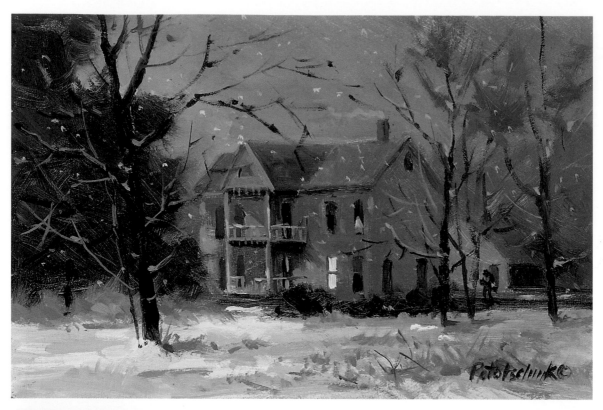

WINTER—DUSK,
THE FORECAST
STORM ARRIVES
John Pototschnik, Oil
6″ × 9″
(15.2cm × 22.9cm)

WINTER—EVENING, MORE SNOW FORECAST
John Pototschnik, Oil
6″ × 9″ (15.2cm × 22.9cm)

IDEA #138 | PAINT SEVERAL PAINTINGS OF THE SAME SUBJECT AT DIFFERENT TIMES OF A DAY

Pototschnik has portrayed the same building under different lighting and winter weather conditions. It is interesting to see how the colors and values shift.

WINTER—MORNING, SUNNY AND CLEAR
John Pototschnik, Oil
6" × 9" (15.2cm × 22.9cm)

VESPERS
Mary Beth Koeze, Pastel
36" × 48"
(91.4cm × 121.9cm)

IDEA #139 | COMPOSE AN INTRICATE DESIGN WITH SHADOW PATTERNS

Translucent petals are one characteristic of flowers. Some of the light shines through single petals; where petals rest in layers, the sunlight is filtered even more.

Tips on Painting Light and Shadow

• The first step in understanding light is to know where the source is. Light is strongest at its source and weaker as it moves away.

• Light rays take a straight path from the source. Anything in the path of the rays is well lit.

• When light rays hit an object, they are deflected, leaving a cast shadow behind the object. The cast shadows fall in the same direction that the light is flowing.

• When there is more than one light source, each source creates its own highlights and shadows.

• Besides direct light, any reflective surface where the light rays fall bounces indirect or reflected light onto adjacent objects.

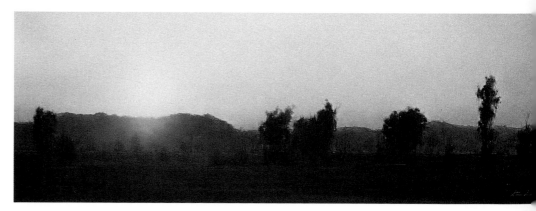

IDEA #140 | PAINT THE SETTING SUN AS IT SINKS BEHIND THE HORIZON

How exciting that one very warm, bright orange shape looks surrounded by the cool blues and greens in the rest of the landscape.

GABRIEL'S GAMES
Steven Gordon, Pastel
18" × 50"
(45.7cm × 127.0cm)

IDEA #141 | PAINT THE LACELIKE SHADOWS UNDER TREES

Although the blossoms in this painting are pretty, the shadows are the most powerful part of the composition. The intense value contrast of dark cast shadows against sun-bleached grass demands the viewer's attention.

ORCHARD
Connie Kuhnle, Pastel
18" × 24" (45.7cm × 61.0cm)

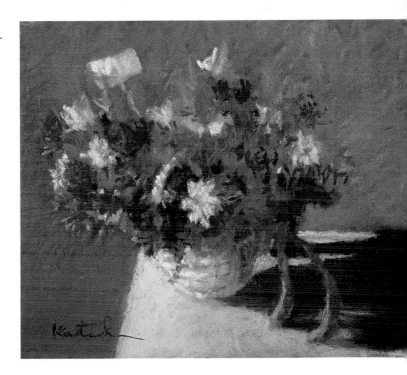

IDEA #142 | PROVIDE BALANCE FOR BRIGHT COLORS WITH THE CONTOURS OF DARK SHADOWS

The shadow at lower right anchors the bouquet.

GIFT OF AN ARTIST
Carole Katchen, Pastel
7" × 8½" (17.8cm × 21.6cm)

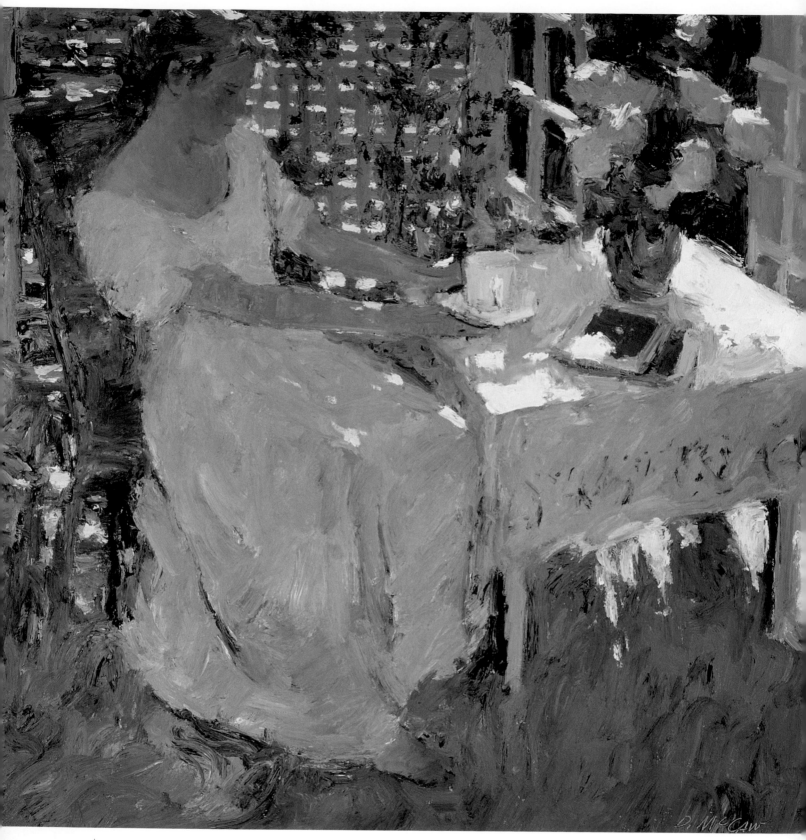

IDEA #143 | PAINT PATTERNS OF LIGHT AND DARK

Light through the latticework provides a textural contrast to the figure. When you design your composition, remember that the pattern of lights and darks is as important as any other shape or figure.

MORNING LIGHT
Dan McCaw, Oil
30″ × 30″ (76.2cm × 76.2cm)

More Shining Ideas

IDEA #144 | LIGHT AN OBJECT FROM BEHIND

With backlighting, the background is brighter than the object. The edges around the object are soft, seeming to vibrate in the bright light. Nothing in the object is as bright as the background unless you shine a second light directly onto the figure.

IDEA #145 | PAINT AN INTERIOR SCENE WITH SUNLIGHT SHINING THROUGH THE WINDOW

The more value contrast you create between the lighted area and the shadows, the stronger the sunlight appears to be. An interesting effect from window light is the striped pattern through blinds. The shape of the window can also give interesting patterns of light. Pay special attention to cast shadows.

IDEA #146 | PAINT THE CITY AT NIGHT

The only light is from such sources as street lamps, neon signs and windows. Pay special attention to the color and reflections of the light.

IDEA #147 | DEFINE THE FORM OF YOUR SUBJECT WITH A SINGLE LIGHT SOURCE

In this painting you can see the light traveling from the window, across the table and onto the figure. The bright highlights also help to define the form of the body.

VIOLET MOMENT
Carole Katchen, Pastel
9" × 12" (22.9cm × 30.5cm)

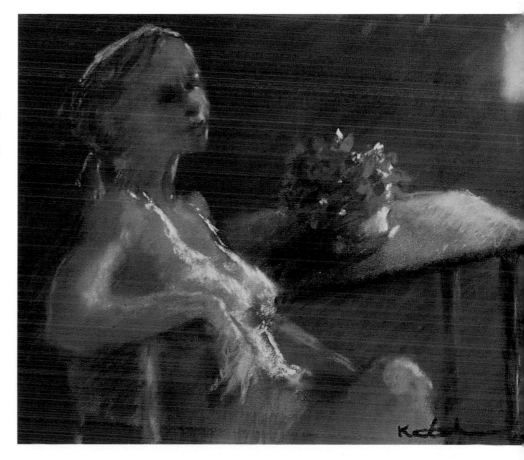

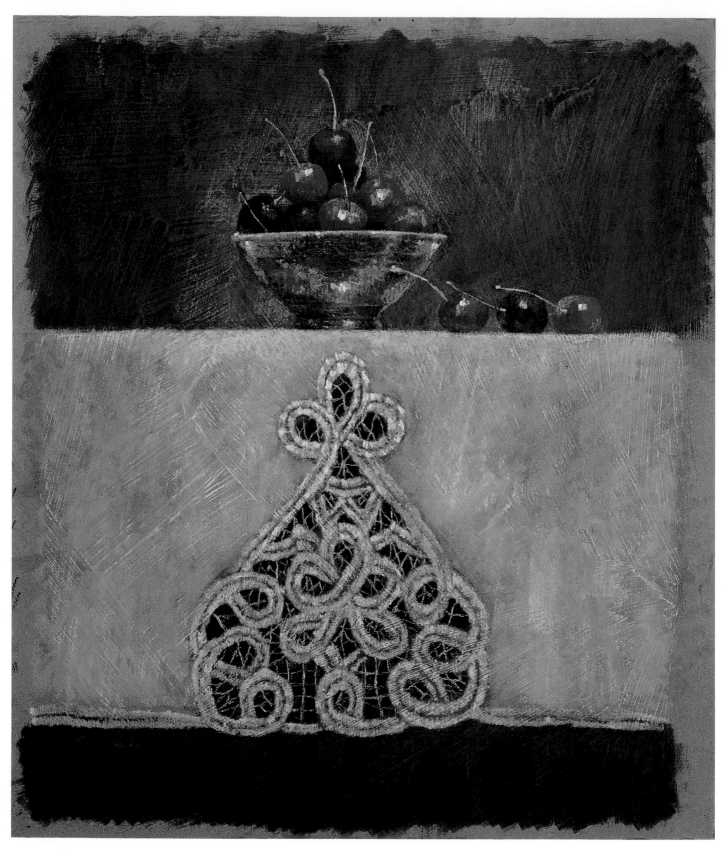

IDEA #148 | PAINT ON A TEXTURED SURFACE

CHERRIES
Lilienne Emrich, Pastel
25" × 23" (63.5cm × 58.4cm)

Even though this is a pastel painting, it has a strong painterly feel because the artist covered her board with thick brushstrokes of primer. Textured papers and heavier weaves of canvas add texture to your painting.

Powerful Textures

There are two kinds of texture in painting. One is the visual representation of the texture in the subject, such as cobblestones, fur, ripples in a lake. The other is surface texture; this is the actual texture created by the artist's technique and materials.

Texture can be a powerful component in a painting. Viewers remember the paintings of Vincent van Gogh (Dutch, 1853–1890) as much for their texture as for their color and subject matter. Those heavy, rhythmic strokes of paint give us great insight into the intense feelings of the artist.

Use single texture throughout a painting to give it an overall tone, or include small sections of texture in the design for contrast or accent. Textural subjects can be combined with surface texture. Whatever textures you include should fit into the total mood and design of the piece.

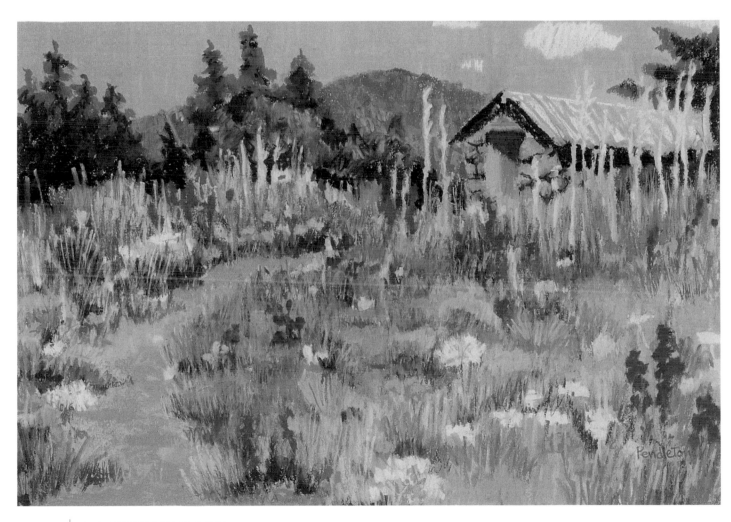

IDEA #149 | CREATE TEXTURES WITH UNBLENDED LINES OF COLOR

Pendleton re-created the lively texture of growing flowers and grasses by painting them with bold lines of unblended color.

BETSY'S RETREAT
Pat Pendleton, Oil Pastel
23½" × 30" (59.7cm × 76.2cm)

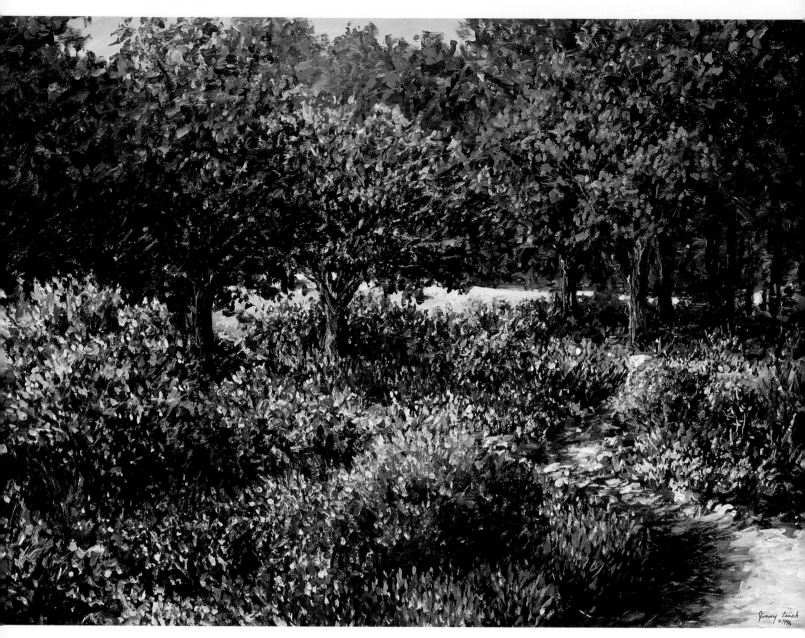

IDEA #150 | PAINT WITH DISTINCT, UNBLENDED STROKES THAT BLEND TOGETHER FROM A DISTANCE

FLOURISHING FLOWERS
Jimmy Leach, Acrylic
30" × 40" (76.2cm × 101.6cm)

Leach uses the Impressionistic technique of optical blending to achieve a vibrant surface texture. This entire garden is created with small bits of color placed next to and on top of each other. Up close you can see the distinct marks, but from a distance the forms blend together, becoming a three-dimensional reality.

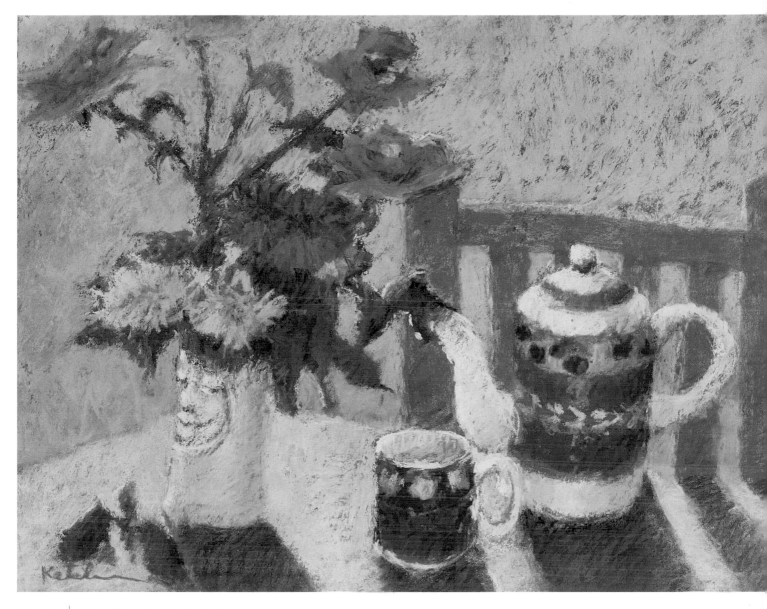

IDEA #151 | TRY SCUMBLING WITH OILS, ACRYLICS OR PASTELS

ENGLISH BREAKFAST TEA
Carole Katchen, Pastel
19" × 25" (48.3cm × 63.5cm)

Scumbling is a process of layering colors so bits of the underlying color continue to show through. Scumbling can be done with oil or acrylic and a brush, pulling the brush lightly across the surface of the painting so pigment is left just on the tops of the previous dry strokes. It can also be done with pastel, using a heavily surfaced texture or building up the surface texture with workable fixative. The bottom layer of color is rubbed in; upper layers of strokes are left unblended.

Paint a Subject With Dots

IDEA #152 | DEVELOP AN IMAGE WITH SIMPLE DOTS OF COLOR

Just as with any other application of paint, you have to remain aware of which are the light and dark areas, and which are the warm and cool areas. It's possible to paint a full composition just with dots. From a distance the forms appear to be solid color, but up close the surface sparkles.

Step One

Step Two

Step Three

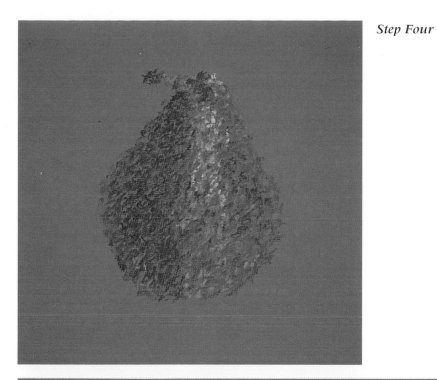

Step Four

PEAR
Carole Katchen, Pastel
15" × 17" (22.9cm × 30.5cm)

Step Five

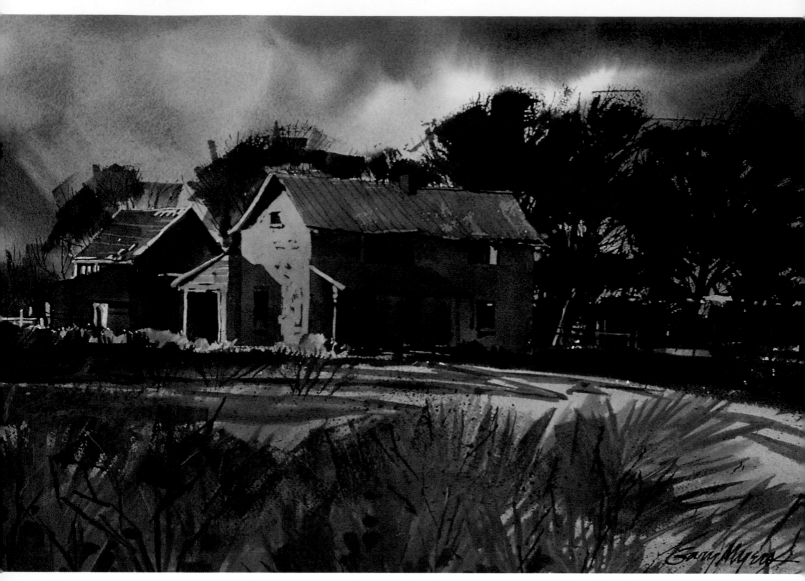

IDEA #153 | COMBINE AT LEAST FIVE DIFFERENT TYPES OF STROKES IN A PAINTING

RANCHOS DE TAOS
Gary Myers, Watercolor
15" × 22" (38.1cm × 55.9cm)

Myers uses many different types of strokes to execute this painting, a full range of watercolor techniques from wet washes to fine lines. The challenge is to maintain a sense of integrity. He helps unify the piece by repeating textures in various places, e.g., the fanlike strokes in the trees and the ground foliage.

More Imaginative Ideas

IDEA #154 | EXPAND YOUR REPERTOIRE OF STROKES AND TEXTURES

Try different types of brushes: flat, pointed, large, tiny, sable, bristle, etc.

IDEA #155 | PAINT AN ENTIRE PAINTING WITH PALETTE KNIVES

IDEA #156 | TRY PAINTING WITH NONTRADITIONAL TOOLS

Paint an entire painting with found objects, sponges, twigs, squares of cardboard, rollers, corks, fingers, squirt bottles and anything else that comes to mind. Using nontraditional tools forces you to be more imaginative in your paint application.

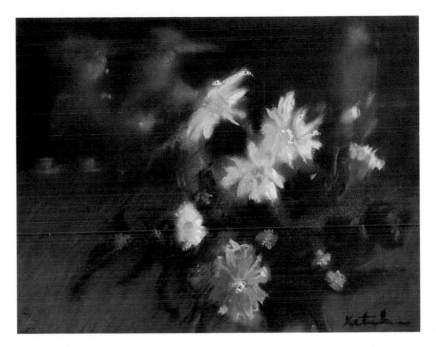

IDEA #157 | BLEND YOUR STROKES FOR A DREAMLIKE PAINTING WITH NO HARD EDGES

With pastels you can blend with a finger or rag. With oils use a sable or fan brush.

IN THE SHADOW OF FLOWERS
Carole Katchen, Pastel
9" × 12" (22.9cm × 30.5cm)

VIOLET SHADOWS
Carole Katchen, Pastel
9" × 12" (22.9cm × 30.5cm)

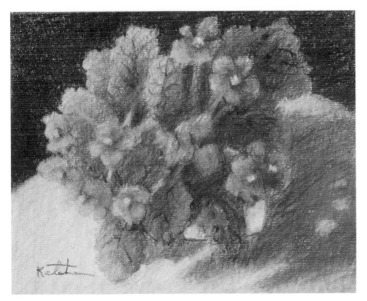

DOROTHY'S VIOLETS
Carole Katchen, Pastel
11" × 15" (27.9cm × 38.1cm)

IDEA #158 | FOR A FRESH WAY OF APPROACHING YOUR SUBJECT, CHANGE THE TYPE OF MATERIALS YOU USE

For the top painting of violets I used soft pastels. The pigment moves easily across the surface of the paper and I tend to do a lot of blending. I tried harder pastels that encourage a more linear approach in the second piece (right). I built up colors with layers of unblended strokes.

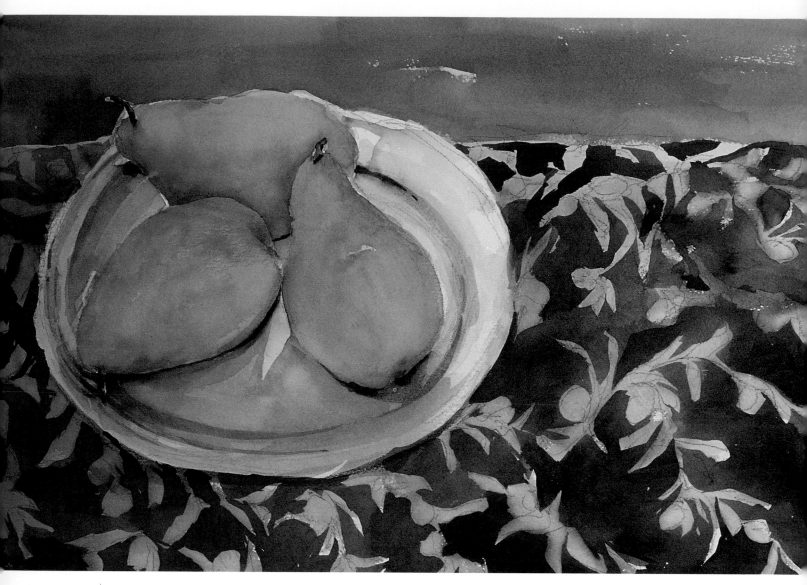

IDEA #159 | PAINT A FLORAL PRINT FABRIC

Intricate patterns can either be rendered in detail or merely suggested, as they are here. In either case, they give compositional weight to what might otherwise be a dull section of negative space.

PEARS & FABRIC
Dolores Justus, Watercolor
20" × 24" (50.8cm × 61.0cm)

Engaging Patterns

Patterns are something like textures, but they tend to dominate a composition more. One small section of bold stripes demands attention and can become the focal point of your painting, even though it may be intended as a less important element in the piece. Patterns can also energize an otherwise unremarkable design.

It's vital to notice how a pattern changes visually with the light and contours of the subject. For instance, stripes appear thickest where they are closest to the eye and thinner as they move back in space. If you don't adapt a pattern to the effects of light and perspective, it flattens out the painting and destroys the illusion of realism.

Set up still lifes that include patterns; study them as you change your viewpoint or alter the light. If you're using fabric, change the draping. Stripes, spots or checks add vitality and joy to a painting, but they require some attention to keep them under control.

IDEA #160 | PAINT THE SYMBOLIC PATTERN OF A FLAG

Here the curving stripes make an interesting counterpoint to the straight stripes of the war bonnet.

BONNET & FLAG
Joseph Melancon, Watercolor
30"×22" (76.2cm×55.9cm)

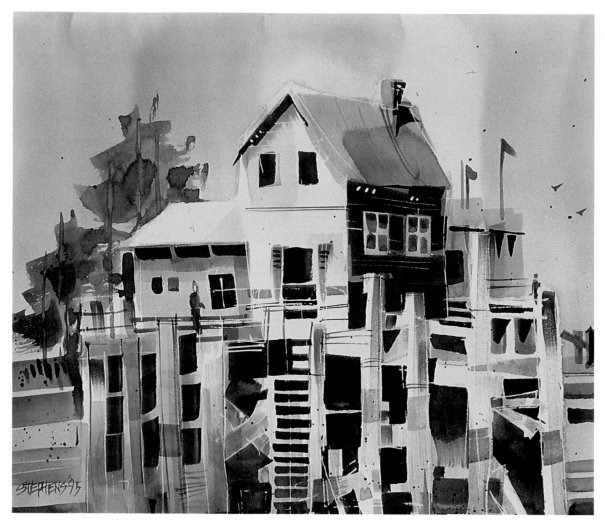

LOW TIDE
Richard Stephens
Watercolor
17" × 19"
(43.2cm × 48.3cm)

IDEA #161 | FIND PATTERNS IN ARCHITECTURE

Look, for instance, at the stairs, windows and other repeated geometric shapes here. Paintings of buildings are more powerful if you remember to look for the patterns of abstract shapes.

IDEA #162 | DRAPE A PIECE OF STRIPED FABRIC FOR A LIVELY ABSTRACT DESIGN

This artist follows the stripes around the curves and into the folds, making all the necessary adjustments of shape and value.

LIGHT AND MORE
Karen George, Watercolor
22" × 30" (55.9cm × 76.2cm)

More Energizing Ideas

IDEA #163 | PAINT A MODEL IN A STRIPED SHIRT, FLOWERED DRESS, CHECKED PANTS OR OTHER PATTERNED CLOTHING

Paint the pattern so it clearly indicates the anatomy of the figure underneath. Pay special attention to subtleties of light and changes in size.

IDEA #164 | CREATE THE ILLUSION OF SPATIAL DEPTH BY USING VANISHING POINT PERSPECTIVE TO PAINT A PATTERNED FLOOR

As a striped or checked floor moves away from the viewer, the pattern gets gradually smaller. This use of vanishing point perspective helps you create the illusion of spatial depth.

IDEA #165 | COMBINE DIFFERENT PATTERNS AND COLORS IN A WHIMSICAL STILL LIFE

The ribbons and fabric seem to be thrown together in a random arrangement, but if you study the composition carefully, you'll see it's a well-balanced design.

A PAIR PLUS A PEAR
Margaret Yates, Watercolor
23" × 30" (58.4cm × 76.2cm)

Various Viewpoints

Changing your point of view is a quick way to get a fresh, often unexpected look at a subject. Place yourself closer or farther away; above or below; inside or outside. Suddenly the relationship of shapes is different, as is, perhaps, your emotional rela-tionship with the subject. The closer you are, the more intimate the scene becomes. The farther away you go, the less personal it appears.

Don't forget about foreshortening. When you look at something from an extreme angle, perspective may drasti-cally alter the appearance of the shape of objects. Remember, an object ap-pears largest where it's closest to you, and seems to get smaller as it recedes in space.

IDEA #166 | GET VERY CLOSE TO YOUR SUBJECT

See and render all the details of color and texture you wouldn't notice from a distance. When you're working in a large format, as this artist has, it also makes the subject seem monumental, an unusual way to perceive a flower bud.

IRIS BUD
Mary Beth Koeze, Pastel
37" × 31" (94.1cm × 78.7cm)

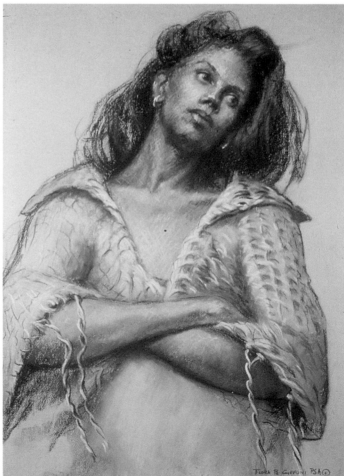

IDEA #167 | PAINT A MODEL FROM BELOW

Looking at this model from below not only changes the shapes of the features but also adds a twist to the girl's attitude. From the viewer's angle, the girl is looking down. Is she haughty, arrogant or just unaware?

SWEATER GIRL
Flora Giffuni, Pastel
24" × 18" (61.0cm × 45.7cm)

More Exciting Ideas

IDEA #168 | REVEAL A SUBJECT'S PERSONALITY IN NEW WAYS BY PAINTING A FIGURE FROM BEHIND

Often the artist relies on facial expression to carry the weight of a figure painting. When you paint a figure from behind, pay more attention to the gesture of the body, the posture, the position of the head, the expression of the hands and the other obscure ways people express themselves.

IDEA #169 | PAINT A LANDSCAPE OR INTERIOR FROM A DOG'S-EYE VIEW

If you were shorter, what would be prominent in your vision? Imagine your eye level at that of a small dog; paint what you would see.

IDEA #170 | PAINT A SCENE THROUGH A WINDOW

Place objects on the window sill to emphasize separate spatial planes.

IDEA #171 | PAINT A SCENE FROM THE OUTSIDE LOOKING INTO A WINDOW

Painting from the outside looking in can add an emotional poignancy to an interior scene. It also presents challenging relationships of light and shadow.

IDEA #172 | INCLUDE A MIRROR IN YOUR PAINTING

A mirror adds interesting complications to your composition, but also gives you more possibilities for repeating shapes and colors within the design.

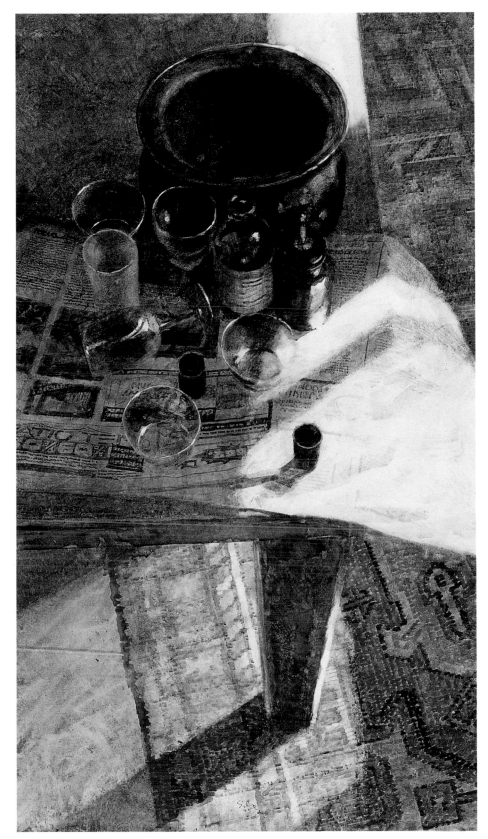

IDEA #173 | VITALIZE A MUNDANE SUBJECT BY PAINTING FROM A DRAMATIC VIEWPOINT

The extreme foreshortening of the table leg in the piece above makes us feel like the floor is a great distance from the tabletop. Silva makes this painting even more intriguing with patches of intense light against deep shadows.

VESSELS
Jerald Silva, Watercolor
48" × 26"
(121.9cm × 66.0cm)

Paint a Bird's-Eye View

IDEA #174 | PAINT LOOKING STRAIGHT DOWN

The hardest part of painting from an extreme angle is seeing what the subject really looks like from that direction. You have to forget everything you already know about how things look and simply rely on your vision.

STEP ONE
Draw Contours, Patterns, Values
Looking straight down on the subject, Martha Bator draws the main contours, patterns and value shapes with charcoal.

STEP TWO
Lay in Color

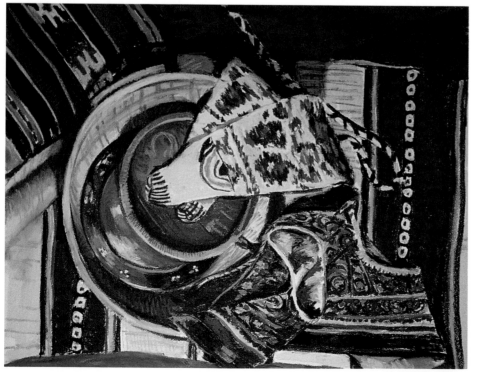

STEP THREE
Solidify Colors

STEP FOUR
Add Final Detail

STILL LIFE WITH VEST
Martha Bator, Pastel
27" × 32" (68.6cm × 81.3cm)

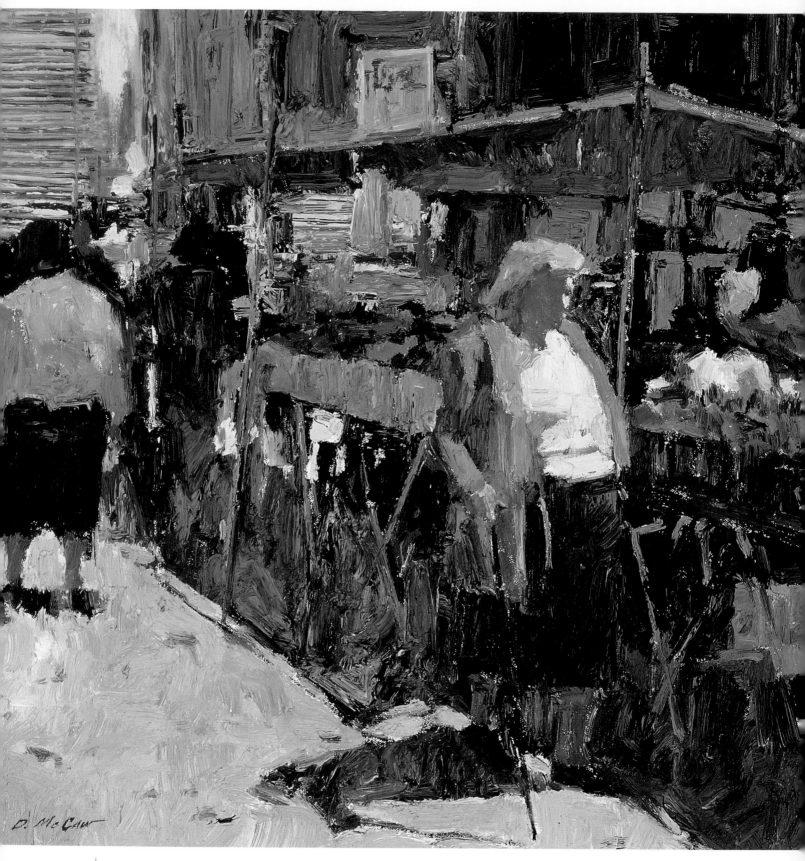

IDEA #175 | GO TO A FLEA MARKET

SUNDAY MARKET
Dan McCaw, Oil
20" × 20" (50.8cm × 50.8cm)

The jumbled assortment of goods provides a great background for the people there. Secondhand and antique stores also work well. Look at the abstract patterns of light and color, as well as individual objects.

Do Something!

When you have absolutely no ideas, just do something . . . anything! The least productive thing you can do is to just sit in front of the easel feeling miserable because there's nothing you want to paint. Taking action of any kind seems to free up the imagination. Walk around the block, go to the grocery store or work in the garden. The important thing is to give your mind and eyes new stimulation.

Look at magazines, books, photos or art. I don't recommend copying other people's images, yet seeing what someone else has done can spark your own creativity. Thumb through your resource materials, such as old sketchbooks. There might be a wonderful idea from the past you've never gotten around to painting.

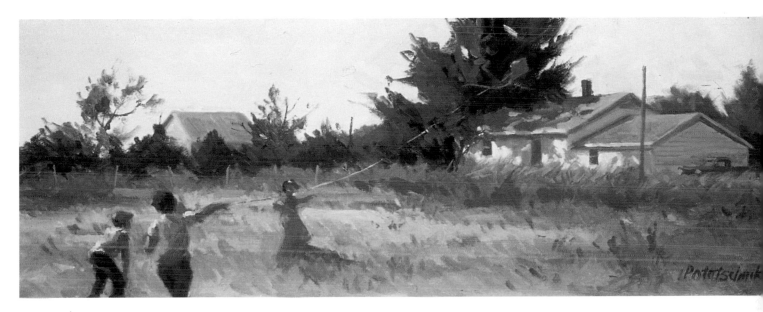

IDEA #176 | FLY A KITE

People playing any kind of game can be lively subjects for a painting. Besides their physical activity, the interaction between people can also be used. Look at body language, gestures and the relationship of shapes.

JUST RIGHT FOR KITES
John Pototschnik, Oil
6" × 18" (15.2cm × 45.7cm)

More Stimulating Ideas

IDEA #177 | GO TO A CAFE

People relaxing over a glass of wine or a cup of coffee make excellent subjects. Lost in their own thoughts or involved in conversations with other people, their body language becomes quite revealing.

IDEA #178 | EMPTY YOUR TOOLBOX, GARAGE, ATTIC, DRAWERS OR CLOSETS TO UNCOVER STILL-LIFE OBJECTS

Though we rarely think about tools except to fix something, they do have wonderful shapes and textures.

IDEA #179 | TAKE A HIKE IN THE WOODS

Look for the small subjects in nature that make special, intimate paintings: a wildflower in bloom, an interesting configuration of branches, a striking pattern of light and shadow on foliage.

IDEA #180 | VISIT A FARMER'S MARKET

Besides being a great place to locate individual pieces of fruit or vegetables for still lifes, the booth displays themselves make colorful subjects: a large pile of bright red apples, a bushel of green cucumbers, a row of orange pumpkins. The large patches of color also provide striking backgrounds for the folks who are shopping or selling.

IDEA #181 | SIT IN ON A BAND OR ORCHESTRA REHEARSAL

Musicians are good subjects for painting on location because they sit relatively still; focus on one musician or a small group. Notice how their gestures and anatomy change as they play. Observe how the horn player's cheeks fill with air, or how the violinist holds the instrument in place by tipping her head.

IDEA #182 | GO TO THE PARK

Within any fair-sized park you'll find a vast array of subject matter—foliage, flowers, monuments, fountains and ponds, as well as all sorts of people and dogs.

SUNDAY STROLL
John Budicin, Oil
9" × 12" (22.9 cm × 30.5cm)

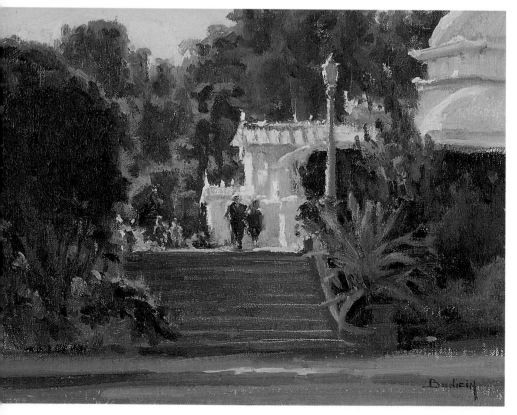

IDEA #183 | PLAY A ROUND OF GOLF

Golf courses are usually beautiful; you can find a wonderful expanse of grass and trees without going far from home. The red flag here provides a wonderful color accent.

WINTER GOLF
Ed Pointer, Oil
9" × 12" (22.9cm × 30.5cm)

IDEA #184 | TAKE A DRIVE

A paved road is an unlikely subject for a painting, but Gordon shows how successful it can be. The secret is to look for interesting designs of value and color.

THE OLD SONOMA ROAD
Steven Gordon, Pastel
36" × 40" (91.4cm × 101.6cm)

DEMONSTRATION
Paint a Country Scene

IDEA #185 | TAKE A TRIP TO THE COUNTRY

This Taiwanese artist has taken an unlikely subject and turned it into a wonderful painting.

STEP ONE
Main Lines and Sky
The artist locates the horizon and other main lines of the composition with charcoal. He begins to block in the sky with a light blue.

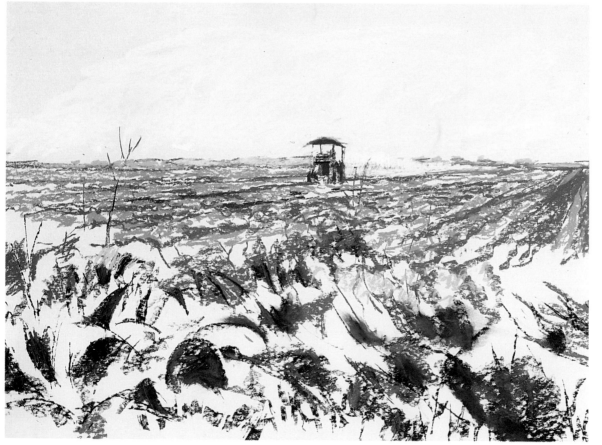

STEP TWO
Earth Texture Sketched In
He loosely sketches in the texture of the plowed earth with earth tones.

STEP THREE
Foreground, Middle Ground, Clouds
He develops the foreground shape with dark values and some color details. He fills out the color in the field and begins to indicate cloud shapes.

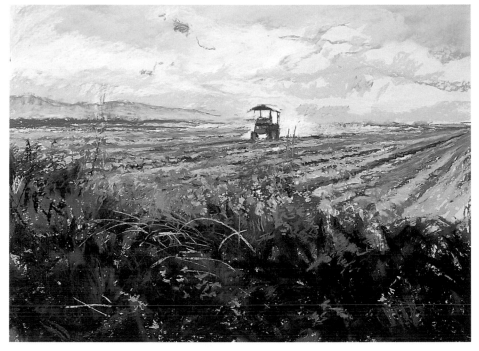

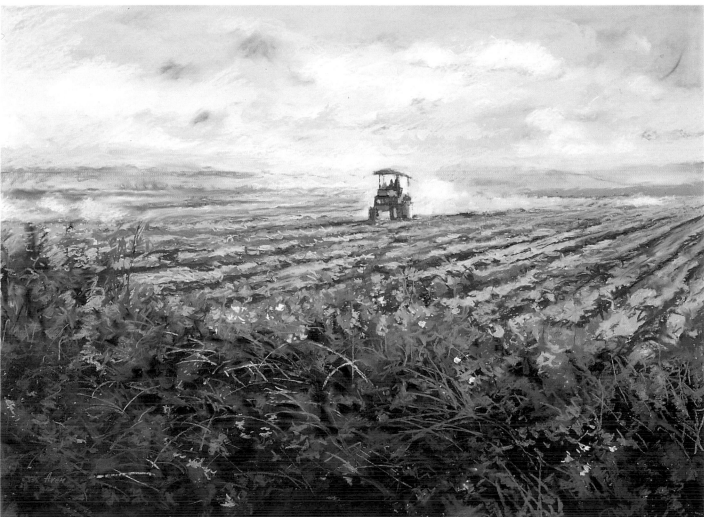

STEP FOUR
Final Details Added
He increases contrast and adds the final details.

APPLYING FERTILIZER
Aven Chen, Pastel
22" × 30" (55.9cm × 76.2cm)

127

Tips on Remembering Ideas

Artists think up great ideas at the most unexpected, inconvenient times; here are some ways to save those ideas for the future.

• Carry a sketchbook with you at all times, and record anything that might be useful in a painting: details of nature or architecture; gestures or physical features of people; ideas for compositions. Include written notes describing possible subjects and general concepts.

• Start an idea file with clippings, photos, color samples or anything that can be used to develop a painting in the future. Don't forget to look through the file periodically to remind yourself of what is there.

FREDONIA RAILYARD
Ed Pointer, Oil
14" × 18" (35.6cm × 45.7cm)

IDEA #186 | EXPLORE A TRAIN STATION

Pointer used the intersecting pattern of tracks as the basis of this painting. Trains themselves also make great subjects because of their size, mechanical shapes and the sentiment we attach to them.

IDEA #187 | VISIT THE ANIMALS IN THE ZOO

Take the time to familiarize yourself with the anatomy and gestures of an animal before you paint it.

CONTEMPLATION
Colleen Newport Stevens, Watercolor
22" × 15" (55.9cm × 38.1cm)

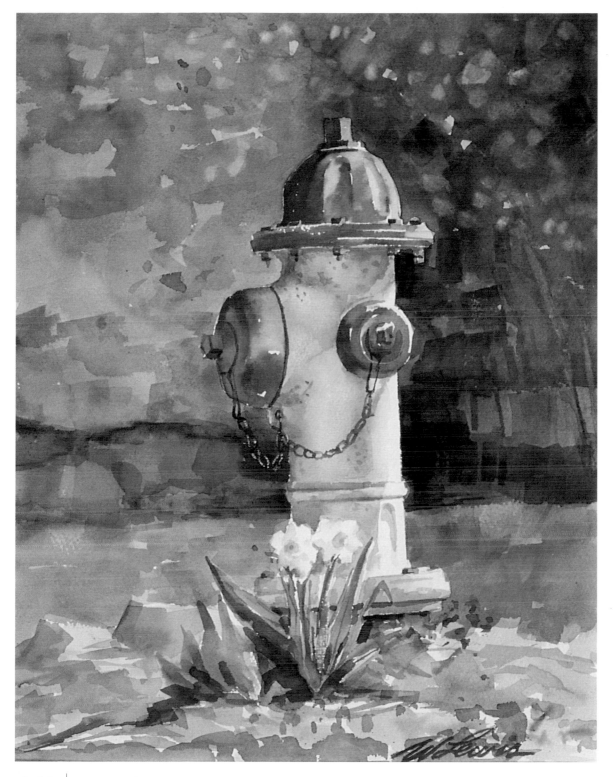

IDEA | WALK AROUND
#188 | THE BLOCK

On every block there are a myriad of possible subjects, objects and combinations of objects we overlook because we see them every day. Take the ordinary and turn it into something noteworthy.

FIREPLUG, EUREKA SPRINGS
Bill Lewis, Watercolor
15" × 12" (38.1cm × 30.5cm)

129

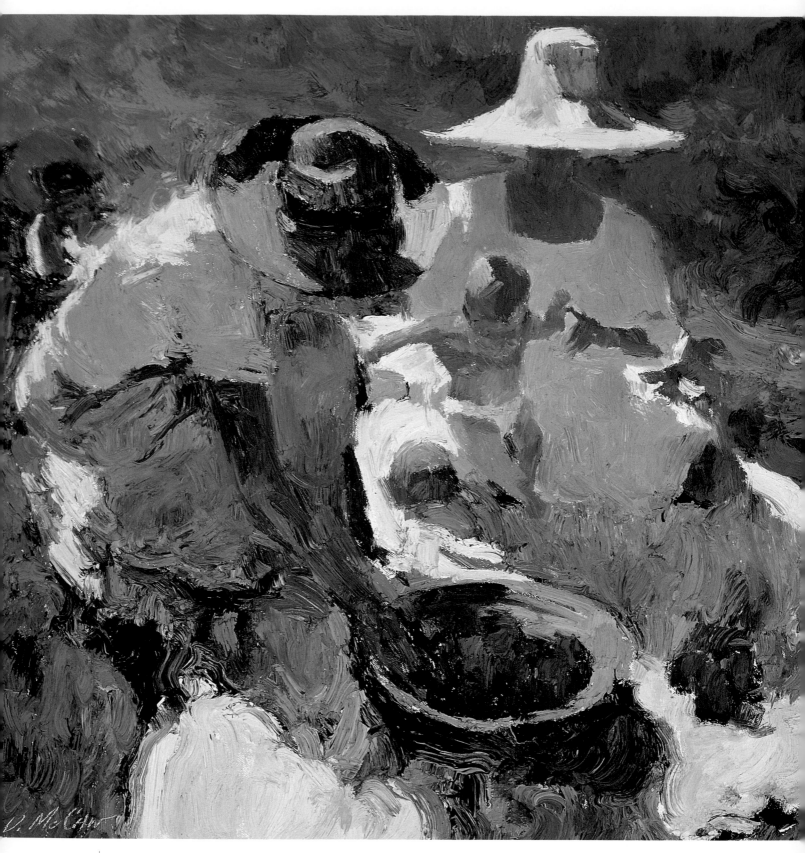

IDEA #189 | HAVE A PICNIC

SISTERS
Dan McCaw, Oil
20" × 20" (50.8cm × 50.8cm)

McCaw simplified this charming scene to a few large shapes of light and color;
we understand it even with the fewest possible details.

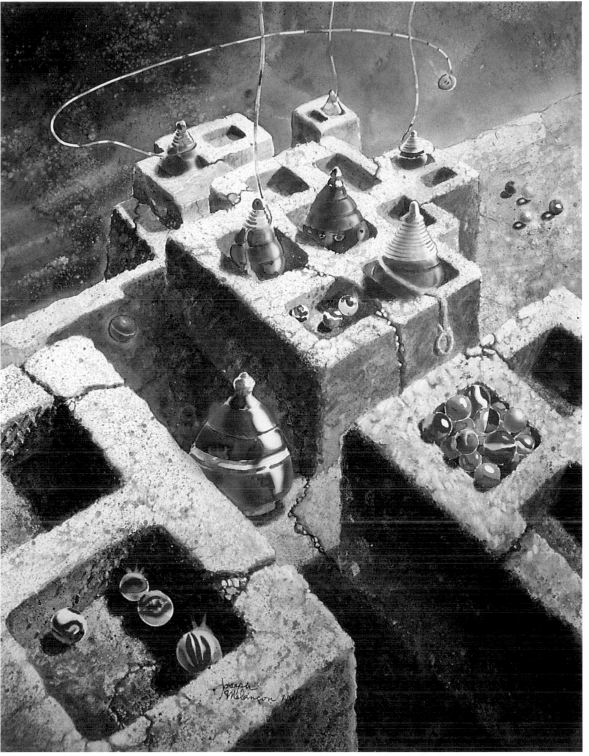

TOP AND A HARD
PLACE
Joseph Melancon
Watercolor
30" × 22"
(76.2cm × 55.9cm)

IDEA | SORT THROUGH
#190 | THE TOY BOX

Melancon makes this assortment of toys more interesting by placing them on
and around cinder blocks, an unlikely combination. He engages the viewer's
curiosity even more by painting some of their strings reaching up into the sky,
with no clue of what's holding them there.

RED GRAPES
Jeff Legg, Oil
9" × 6"
(22.9cm × 15.2cm)

Make a Good Painting Great

This book is filled with dozens of ideas for painting interesting subjects with good composition. But what makes some paintings go beyond good to being really special? What makes a good painting better or even brilliant? These are questions I've asked myself as I judge painting competitions. While clicking through slides of hundreds of entries, now and then one makes me stop for a second look.

The best paintings *compel* the viewer to take a second look. They strike the eye while engaging the imagination and emotion of the viewer. Here are some suggestions for enriching your own painting ideas:

• Go beyond the ordinary, not only with subject and composition but with technique. Sometimes I see a painting so brilliantly painted, it takes my breath away. It doesn't matter what the subject is. I'm dazzled by the virtuosity of the artist. Never be satisfied with being competent, with just getting by. Go for brilliance.

• Surprise the viewer by including unexpected elements (a spot of red in a field of green), using unusual subjects or painting a common subject in a way it's rarely seen (packaged cupcakes next to elegant roses). These are the kind of surprises that delight and intrigue the viewer; let your painting expand the experience of the person who looks at it.

• Tell a story. People love stories, and they're attracted to paintings with a narrative element. It doesn't have to be a story with a beginning, middle and end. It's enough that the painting suggests something interesting going on. The viewer fills in the details.

• Include something in your painting a viewer can relate to in a personal way, that conveys a mood or a relationship between people. The viewer should be able to look at it and say, "This painting is about me."

IDEA #191 | **TELL A STORY**

Legg's painting of a complete bunch of grapes (right) is beautiful. Yet the painting with grapes missing (left) is *wonderful*. It has the technical excellence of the other, but also tells a story. Somebody ate those grapes; the viewer wants to know who.

FRUIT OF THE VINE
Jeff Legg, Oil
10" × 7½" (25.4cm × 19.1cm)

EL ROI-TAN, FLAG & DRUM
Joseph Melancon, Watercolor
30" × 22" (76.2cm × 55.9cm)

IDEA #192 | CREATE A SENSE OF DRAMATIC MYSTERY WITH INTENSE LIGHT AND SHADOW

We think the giant shadow belongs to the child who owns these toys, but it's so big and ominously dark, we can't be sure. The toy figures look intriguing because of the bright highlights around them.

IDEA #193 | CREATE A MOOD

This is a strange, somewhat eerie painting. The mood is created by the stark rendering, the monochromatic color with a few red accents and the dramatic lighting.

ONE OF THESE DAYS THESE BOOTS
Warren Criswell, Oil
50" × 37" (127.0cm × 94.1cm)

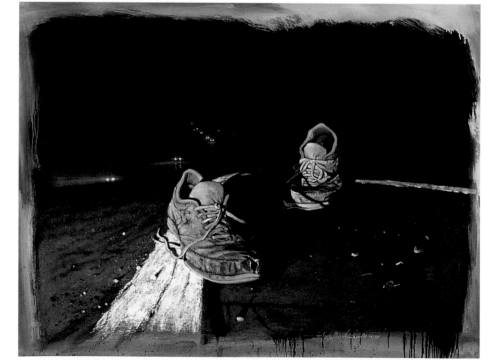

IDEA #194 | PAINT A CONVERSATION

CLUB SCENE—TURQUOISE STUDY
Carole Katchen, Pastel
12" × 9" (30.5cm × 22.9cm)

In my paintings of people, I generally try to leave something for the viewer to add. In this case the viewer gets to make up the conversation. It's a wonderful device for involving the viewer with the painting.

IDEA #195 | PUT YOURSELF IN THE PICTURE

This would have been an interesting painting just because of the lighting and position of the model, but the artist makes it even more intriguing by adding his own foot, a visually discordant element.

SKYLIGHT
Jerald Silva
Watercolor
36" × 28"
(91.4cm × 71.1cm)

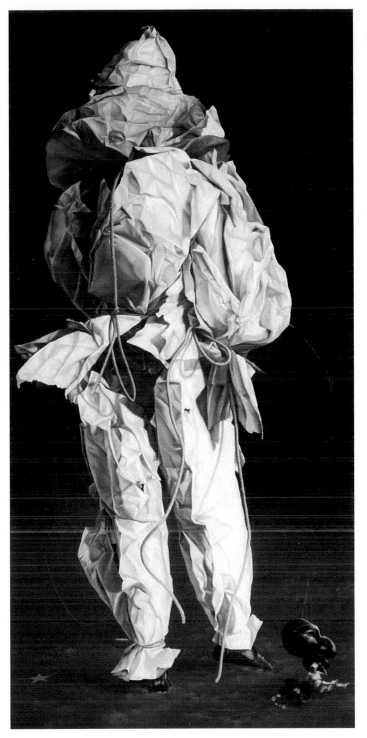

IDEA #196 | PAINT SOMETHING FROM YOUR IMAGINATION

Is this a puppet, a man wrapped in fragments of paper or an empty costume? The ambiguity is what makes the piece intriguing, especially since it's painted in such a crisp, realistic manner. It's not necessary for the viewer to understand the painting, as long as it's visually compelling.

PULCINELLA'S VOCATION
Renzo Galardini, Oil
40″ × 20″ (101.6cm × 50.8cm)

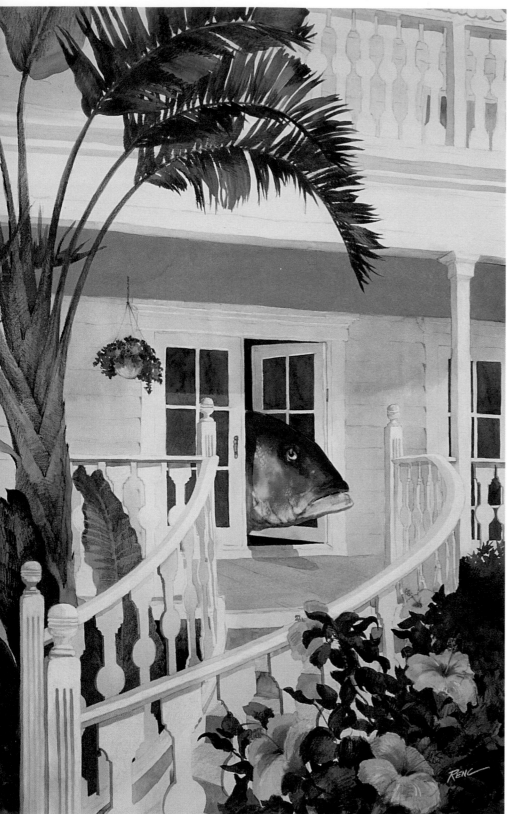

IDEA #197 | ADD A DELIGHTFUL SURPRISE TO YOUR PAINTING

Renc paints a comfortable Southern home with a palm tree, flowers, a wooden bannister and a fish swimming out the front door. The joke works because of the graceful realism of the painting.

WILEY DUNEDIN GROUPER
Bill Renc, Watercolor
36" × 26" (91.4cm × 66.0cm)

IDEA #198 | TRY AN UNUSUAL FORMAT

This simple landscape becomes a jewel of a painting because of its unusual shape and handcrafted frame.

BLOOMING DESERT
Brad Aldridge, Oil
22" × 14" (55.9cm × 35.6cm)

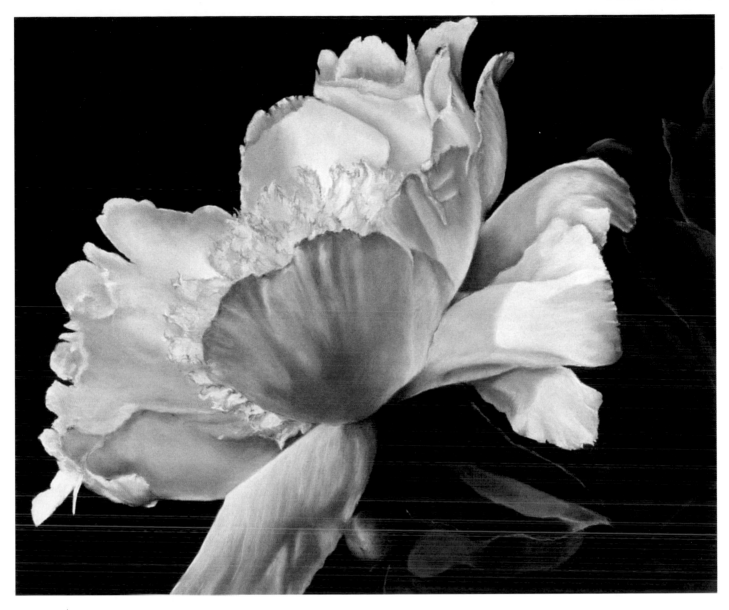

IDEA #199 | DRAMATIZE AN ORDINARY SUBJECT

GRANDVIEW
Mary Beth Koeze, Pastel
31" × 37" (78.7cm × 94.0cm)

Koeze makes this single flower seem important by enlarging it to a grand scale and painting it close up, so the blossom fills the composition; bold lighting is also used to maximize the contrast of a white flower against a black background.

Great Ideas are Everywhere

How do you know if an idea is a good one? Ask yourself if it's something you care enough about to stick with until you've created a great painting. If the idea fascinates you, if you truly believe it's important to express, then it's definitely a good idea. Maybe even a great one.

IDEA #200 | KEEP YOUR EYES OPEN AND LET YOUR IMAGINATION RUN FREE. IDEAS ARE EVERYWHERE!

Two hundred great ideas for painters might seem like a lot, but it's only the beginning. For every artist there's an infinite selection of ideas available.

Contributors

BRAD ALDRIDGE
Blooming Desert, collection of Taylor's Contemporary Fine Art © Brad Aldridge.

BROOKE ALLISON
Old English, collection of David and Debbie Auerbach © Brooke Allison.

MARTHA BATOR
Still Life With Vest © Martha Bator.

JOHN BUDICIN
Matillja Poppies; Poppies in Delftware; Summer Arrangement; California Pasture; Evening Radiance; Day Break; Golden Glow; The White Camelia; Sunday Stroll © John Budicin.

AVEN CHEN
The Shadow; Applying Fertilizer © Aven Chen.

WARREN CRISWELL
Feet, collection of Taylor's Contemporary Fine Art; One of These Days These Boots, collection of Drs. Janet and Steven L. Cathey © Warren Criswell.

ANATOLY DVERIN
My Mother; Clementine; Still Life With Russian Samovar © Anatoly Dverin.

WILBUR ELSEA
Mooring at Seabrook, private collection; Flint Hills Sunset, private collection; Tybee Island, private collection © Wilbur Elsea.

LILIENNE EMRICH
California Peaches; Three Pears/Chemical Lace; Red Pears & European Lace; Costumed Lady; Ballerina; Cherries © Lilienne Emrich.

RENZO GALARDINI
The Star Planter; Pulcinella's Vocation © Renzo Galardini.

KAREN GEORGE
Empty Crystal IV, collection of Mr. and Mrs. Bill McCoy; Light and More © Karen George.

FLORA GIFFUNI
Sweater Girl © Flora Giffuni.

STEVEN GORDON
Mount Tamalpais; Below Oakville Grade; Reflecting; Gabriel's Games; The Old Sonoma Road © Steven Gordon, Steven Gordon Studio Gallery.

RANDY GRODEN
Self Portrait © Randy Groden.

GLENNA HARTMANN
Lighthouse on Anacada Island; Backcountry Sunrise; Spring Foothills; Barnsdall Rio Grande Gas Station © Glenna Hartmann.

MARIAN HIRSCH
Wishing Well, D.A.B.S.; Sea Pines, collection of Merrill-Lynch; Waterwillows I–Wills Point © Marian Hirsch.

DOLORES JUSTUS
Not a Pair; Points of Interest; The Ridge; Pears & Fabric © Dolores Justus.

KATHLEEN KALINOWSKI
Wild Roses, private collection © Kathleen Kalinowski.

CAROLE KATCHEN
New York Sunflowers, collection of Mr. and Mrs. Ed Herschewe; Temptation in the Afternoon, courtesy Telluride Gallery of L.A.; Birthday Tulips; Desert Brides, courtesy Legacy Gallery; The Sisters' Geraniums, courtesy Collector Gallery; Promise of Spring, courtesy Am. Legacy Gallery; Sax in the Afternoon, courtesy Legacy Gallery; Mardi Gras, collection of Mr. and Mrs. Ed Pointer; Lynn Ann's Nude, collection of Lynn Anne Kamil; The Promise, courtesy Saks Gallery; Flight of Fancy, private collection; Napolean House Bar, courtesy Legacy Gallery; At the Jazz Festival, courtesy Legacy Gallery; Tell It on the Mountain, courtesy Legacy Gallery; Gift of an Artist, courtesy Madison Ave. Art Gallery; Violet Moment, collection of Jody DePew McLeane; English Breakfast Tea, courtesy Legacy Gallery; Pear; In the Shadow of Flowers, collection of Ros Rosenberg; Violet Shadows, courtesy Legacy Gallery; Dorothy's Violets, private collection; Club Scene—Turquoise Study, private collection © Carole Katchen.

MARY BETH KOEZE
Rubrum Lily, private collection; Vespers, private collection; Iris Bud, collection of the artist; Grandview, collection of the artist © Mary Beth Koeze.

CONNIE KUHNLE
Morning Garden; Mary's Garden; Here Today, Grown Tomorrow; Orchard © Connie Kuhnle.

VICKY KUYKENDALL
Willie the Ranch Cat; Out of Bounds—Black Bear © Vicky Kuykendall.

JIMMY LEACH
The Lake's Edge; Flourishing Flowers © Jimmy Leach.

JEFF LEGG
Pomegranates and Artichoke, collection of Dr. and Mrs. D. Mitchell Stinnett; Prune Plums, courtesy of American Legacy Gallery; Still Life With Tang Horse, private collection; Red Grapes, collection of Mr and Mrs. George Brett; Fruit of the Vine, private collection © Jeff Legg.

JO ANN LEISER
Kitchen Towel 1; Kitchen Towel 2; Kitchen Towel 4 © Jo Ann Leiser, winners of Pen & Brush and Salmagundi Club awards.

BILL LEWIS
Morning Light; Flea Market; Fireplug, Eureka Springs © Bill Lewis.

JIM MARKLE
Achill Sound; Brendon Bridge; On the Isle © Jim Markle.

DALE MARTIN
Vermejo, winner of Eileen L. McCarthy Award, Salmagundi Club, 1996 © Dale Martin.

LYDIA MARTIN
Shelves, collection of the artist © Lydia Martin.

DAN MCCAW
Afternoon Light; Still Life; Helping Hand; Newsstand Corner; The Bather; Memories; Cityscape; Quiet Moment; Morning Light; Sunday Market; Sisters © Dan McCaw.

JOSEPH MELANCON
Bonnet & Flag, private collection; Top and a Hard Place, private collection; El Roi-Tan, Flag & Drum, collection of the artist © Joseph Melancon.

R.L. MICHAELIS
Seven Pears © R.L. Michaelis.

SHARON MOODY
Lemonade; One O'Clock Post, collection of A. Foster Higgins & Co., Inc. © Sharon Moody.

GARY MYERS
Coe Ranch; Ranchos de Taos, courtesy Benson Fine Art © Gary Myers.

MARY NORMAN
Lady X © Mary Norman.

LINDA PALMER
Tree of Hearts © Linda Palmer.

PAT PENDLETON
Blooming Meadow, private collection; Shadows, private collection; Betsy's Retreat, private collection © Pat Pendleton.

MARY ELLEN PITTS
Glory, Morrison-Woodward Gallery © Mary Ellen Pitts.

ED POINTER
Arroyo Hondo; Winter Golf; Fredonia Railyard © Ed Pointer.

JOHN POTOTSCHNIK
Midwestern Sunset, collection of Mr. and Mrs. Jerry Wade; Bickleigh Garden, collection of Mary Upsher; Master Series #1—Millet; Vermont Autumn, collection of Jane Mueller; Morning in Rhonda, collection of Val Fenwick; Sunset at Leicester, collection of James Meehan; Winter—Dusk, the Forecast Storm Arrives, collection of Mr. and Mrs. Mack Colt; Winter—Evening, More Snow Forecast, collection of Mr. and Mrs. Mack Colt; Winter—Morning, Sunny and Clear, collection

of Mr. and Mrs. Mack Colt; Just Right for Kites, collection of Tracy McGee © John Pototschnik.

STAN RAMES
Granny Messanger; Victorian © Stan Rames.

ROSE MARIE REDDING
Truckin' Two, collection of the artist © Rose Marie Redding.

RUTH REININGHAUS
Ching Vase & Silver Dollars, private collection; Tibetan Copper, collection of the artist; K'ang-Hsi Vase, private collection; Bavarian Porcelain & Crab Apples, private collection © Ruth Reininghaus.

BILL RENC
Wiley Dunedin Grouper, The Painted Fish Artist's Studio & Gallery © Bill Renc.

MARLIN ROTACH
Ariel's Window, courtesy of American Legacy Gallery; Plaza Evening, collection of Robert Whiteman; Fountain of Bacchus, courtesy of Hilliard

Gallery; Westport Reflections, collection of James L. Clark © Marlin Rotach.

ELIZABETH SANDIA
Acequia Madre Courtyard, winner of Pastel Society of America award, 1996 © Elizabeth Sandia.

CAROL ANN SCHRADER
Spickler's Dairy © Carol Ann Schrader.

JERALD SILVA
The Corks; Water Cooler; Too Many Jars, collection of Heather Mobarak; Two Models With Their Mother; Model With a Slide, collection of Jerrold and Barbara Perry; Vessels; Skylight © Jerald Silva.

BUTLER STELTEMEIER
Roses With Little Debs; Olives With Bug Book © Butler Steltemeier

RICHARD STEPHENS
Oil Rig; Retired Farmer; Hardwood Mill; Low Tide © Richard Stephens.

COLLEEN NEWPORT STEVENS
Sheep Feast III, collection of the artist; Alamos Afternoon, collection of the artist; Contemplation, collection of Grace Ballard © Colleen Newport Stevens.

URANIA CHRISTY TARBET
Sunkissed Sunflowers, private collection; Victorian Bouquet; High Tide—Cambria, courtesy Simil/Regal Gallery; Monet's Path, private collection © Urania Christy Tarbet.

PENNY WILKINSON
Young Lieutenant's Wife © Penny Wilkinson.

MARGARET YATES
A Pair Plus a Pear, private collection © Margaret Yates.

ROBIN YOUNG
California Sunshine; Cowboy Conversation; Monhegan Deer People © Robin Young.

XIANG ZHANG
A Cup of Coffee; Tap Dancers; Fishing Village © Xiang Zhang.

INDEX